EVERGLADES
National Park

impressions

photography and text by
Tom and Therisa Stack

FARCOUNTRY
PRESS

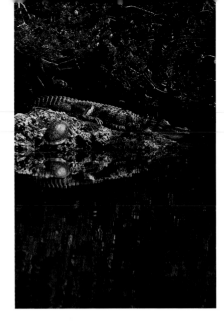

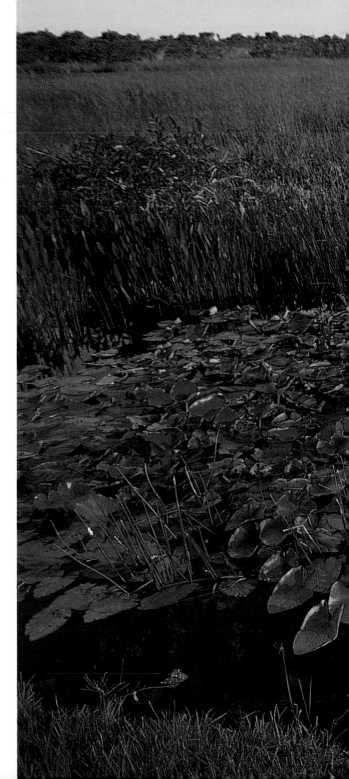

ABOVE: Turtle and American alligator sunbathing together alongside U.S. Highway 41, Tamiami Trail.

RIGHT: Water lilies amid an expanse of sawgrass flanking Anhinga Trail at the Royal Palm Visitor Center.

TITLE PAGE: Spectacular Everglades sunrise.

FRONT COVER: Vibrantly colored roseate spoonbill foraging for food around the roots of a red mangrove.

BACK COVER: The prop roots of red mangrove trees, these exposed at low tide, play a vital role in stabilizing and shielding coastal lowlands.

ISBN 1-56037-301-6
Photography © 2004 Tom and Therisa Stack
© 2004 Farcountry Press
Text by Tom and Therisa Stack

For more information on our books write: Farcountry Press, P.O. Box 5630, Helena, MT 59604; call (800) 821-3874; or visit www.farcountrypress.com

Created, produced, and designed in the United States. Printed in China.
08 07 06 05 04 1 2 3 4 5

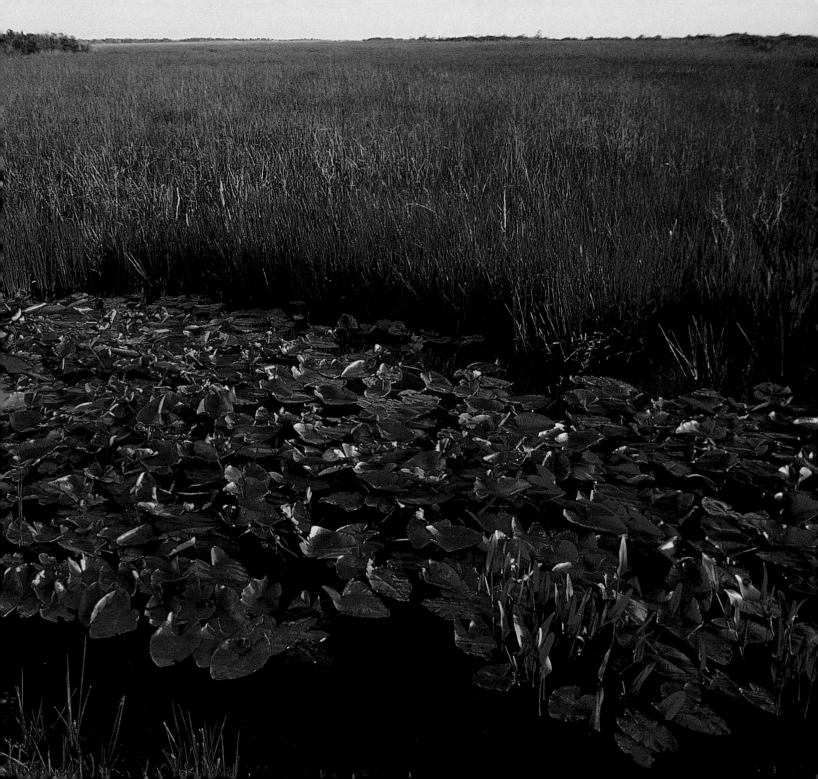

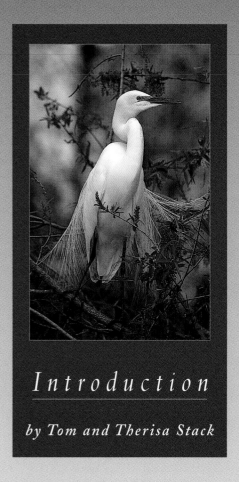

Introduction

by Tom and Therisa Stack

*T*he resonance of wings beating in concert fills the dawn air as a vast, mixed flock of white ibises and egrets lift off in unison from the swaying sawgrass.

The silence of a magical evening is broken only by the soft sound of a kayaker's paddle gently pushing through the water. Water droplets from the raised paddle form concentric circles on the tranquil surface of Florida Bay.

The love song of the alligator—an eerie, sonorous, bass bellow of a courting bull—permeates the Everglades in spring. As loud as thunder, these peculiar noises can be heard miles away.

Impressions are made in a fleeting moment of time, an eye blink, a second of unconscious thought pattern, a memory stirring from within. Our impressions of Everglades National Park have not been captured in a brief moment but rather during a lifelong appreciation of the Everglades' startling beauty and spectacular wildlife. We are honored to share here a glimpse of the Glades we know and love.

Everglades National Park was established in 1947, largely through the efforts of pioneering environmentalist Marjorie Stoneman Douglas. This astounding woman's lifelong crusade to save the Everglades ended only a few years ago upon her death at the age of 108. Covering 1.4 million acres and hosting 300 species of birds, Everglades National Park has been designated a World Heritage Site, an International Biosphere Reserve, and a Wetland of International Importance. As the only subtropical preserve in North America, the totally unique Everglades landscape is a mosaic of mangroves, cypress swamps, hardwood hammocks, and sawgrass wetlands. This is America's celebrity wetland and, unfortunately, our most threatened.

Regretfully, levees, canals, and dams have dissected most of the Everglades. Today, nearly 17,000 square miles of irreplaceable biological treasures are protected within Everglades National Park, while highways, condominiums, and strip malls compete for space along the park boundaries.

Nearly all of the Everglades is actually submerged under several inches of water, which slowly flows southward from Lake Okeechobee to Florida Bay. With all of these shallow-water feeding areas, the Everglades is renowned for abundant bird life, especially large wading birds. Its strategic geographic location on migratory bird flyway routes cannot be overlooked.

In addition, the Park is home to twenty-two endangered and threatened species. The Florida panther, West Indian manatee, American crocodile, wood stork, and snail kite all hang onto their precarious existences while battling the encroachments of civilization.

The Everglades is a fragile and complex ecosystem hanging in a delicate seasonal balance between dry and wet. During the dry season, from December to April, fish journey to the few remaining deeper ponds and wading birds nest—a concentrated food source is crucial for their survival. The wet season usually begins with the May thunderstorms. In a short amount of time, the Everglades landscape once again becomes nearly covered by water. Fish and insects spawn and mate, thus enabling the food chain to be replenished.

The wet and dry seasons are cyclical. If one of the seasons should last longer or shorter than normal, the fragile ecosystem is severely altered, resulting in either the extended life or premature death of many creatures. Increased demands for water by both a growing population and agriculture drastically affect the water table as well.

While there are five visitor centers located throughout different areas of the Park, to experience the real Everglades, it's necessary to get out of the car. The easiest and most convenient way to capture of taste of the Everglades is to take a tram ride at the Shark Valley Visitor Center on Tamiami Trail, U.S. Highway 41. During a 15-mile loop ride with a halfway stop at an observation tower, you'll enjoy numerous encounters with wildlife as you watch vast sawgrass wetlands unfold before your eyes. You can also bicycle the route; rentals are available at the Visitor Center.

Another way to experience to the Park is to take a stroll on the boardwalk at the renowned Anhinga Trail less than 4 miles inside the main entrance. This easy 0.5-mile walk provides an up-close-and-personal view of how the alligators, birds, and other wildlife interact with their environment.

Since so much of the Park is made up of shallow waterways and marine estuaries, canoeing and kayaking are excellent ways to explore. Perhaps the easiest paddling can be found at Nine Mile Pond; the route through the shallow sawgrass is marked with numbered white poles.

An exceptionally beautiful paddling route is the Turner River Trail, which begins by launching at the H. P. Williams Roadside Park on U.S. Highway 41. This lovely 8-mile downstream trip ends at the rustic fishing village of Chokoloskee, where you can pre-arrange for someone to drive you back to your vehicle at the launching point. The lovely Noble Hammock Trail is a mere 2-mile loop through mangrove canopies.

For the true excitement junkie, try the Hells Bay Canoe Trail, which, as the name implies, is a far more challenging, narrow, and twisty route through the mangroves. If you want a chance to see both rare greater flamingos and endangered American crocodiles, launch at the Flamingo Visitor Center and paddle east into Snake Bight.

The truly adventurous, seasoned kayaker may want to tackle the Wilderness Waterway, a 99-mile inland water route from Flamingo Visitor Center west to the Gulf Coast. Numbered markers will guide you along the way, and there are several campsites and elevated palm-thatched chickee huts, which require a backcountry permit to use.

Florida Bay is truly a magical part of the Park, playing host to islands and islets too numerous to list. Solitude is sovereign here at the base of an endless sky. Constituting one-third of the Park and covering a thousand square miles, the shallow waters of Florida Bay are home to the endangered West Indian manatee, bottlenose dolphin, and numerous game fish. Florida Bay's importance as a nursery for lobster, shrimp, and numerous fish species cannot be overstated. The islands, or keys, serve as vital nesting sites and rookeries. The best way to visit, explore, and fish these remote areas is to arrange for a backcountry flats boat charter, specializing in eco-tours, either at Flamingo Visitor Center or out of the Upper Florida Keys.

To some the Everglades seems to be a swamp—but a closer look will truly take your breath away. The simple quiet and unmistakable natural beauty will surround you and leave an indelible imprint on your soul. Gather your impressions around you—and remember.

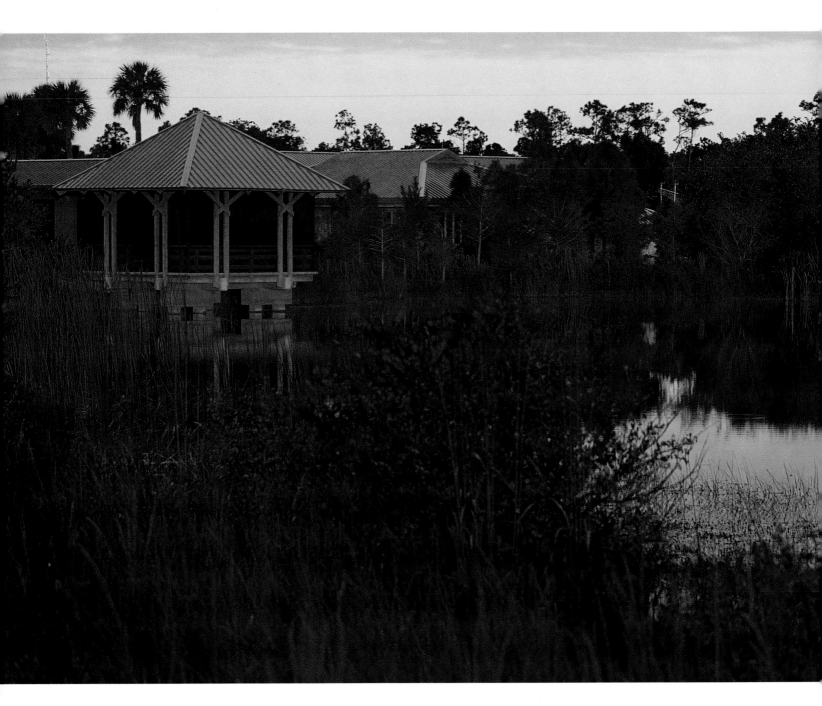

FACING PAGE: Daybreak at the Ernest F. Coe Visitor Center.

BELOW: Striking tri-colored heron posing for appreciative bird watchers, Shark Valley.

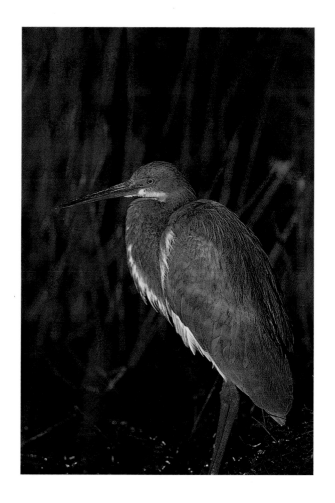

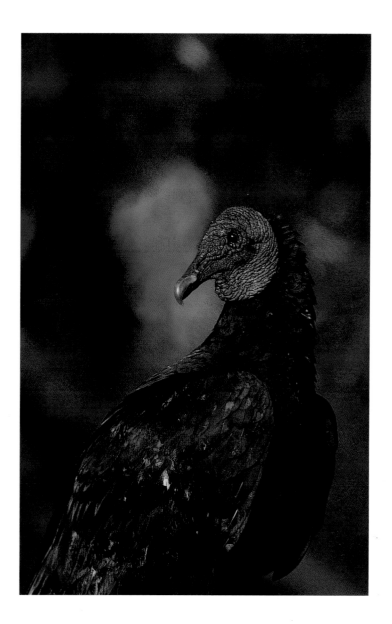

ABOVE: Two species of vultures are found in Florida: the black vulture (pictured) and the turkey vulture.

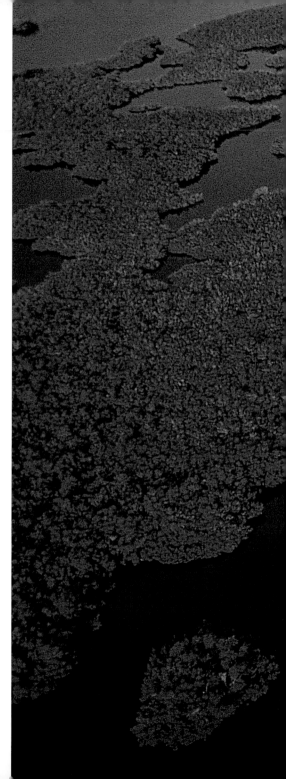

RIGHT: Numerous mangrove-covered islands dot the Everglades coast in Florida Bay.

BELOW: Stealthy American alligator gliding slowly through a pond cloaked in duckweed.

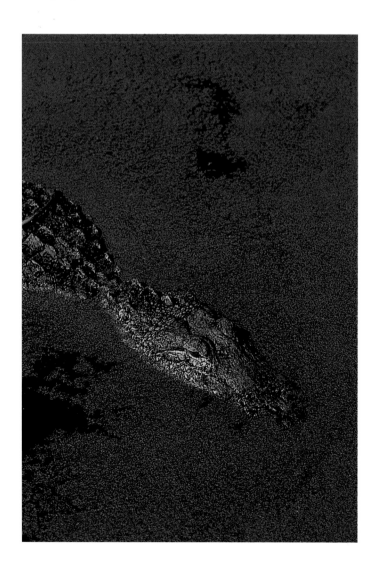

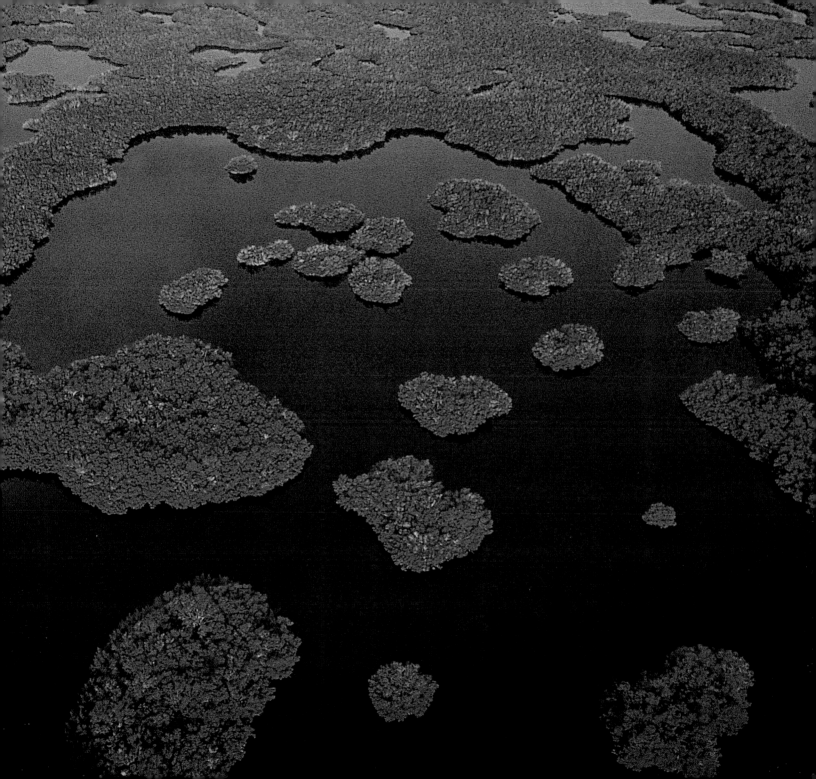

RIGHT: The elusive Florida panther is an endangered species with an uncertain future.

FAR RIGHT: Brown pelicans taking a break in the branches of a red mangrove.

BELOW: Raccoon foraging for food in an estuarine pond.

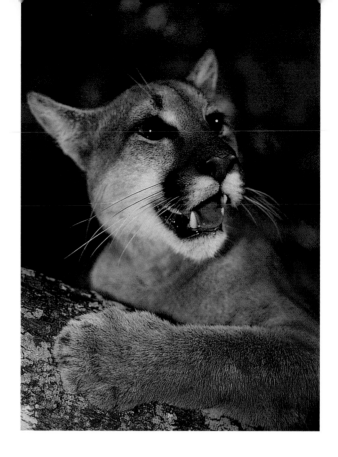

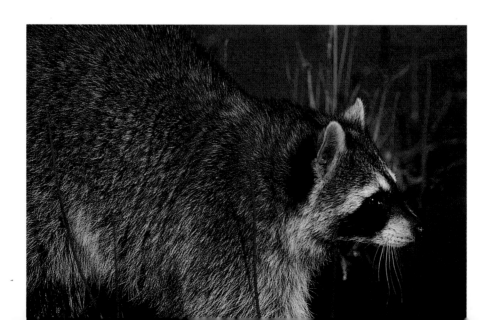

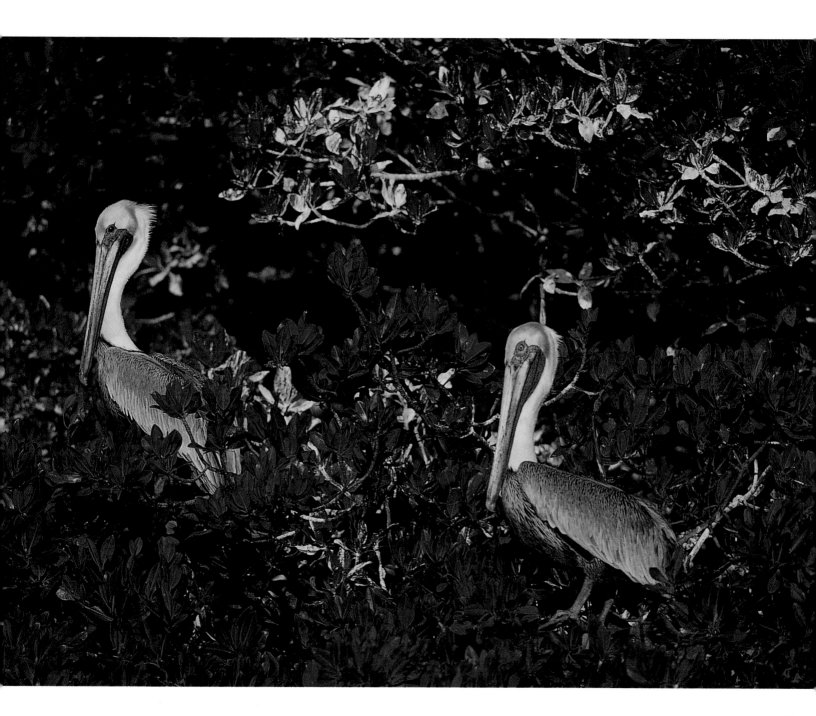

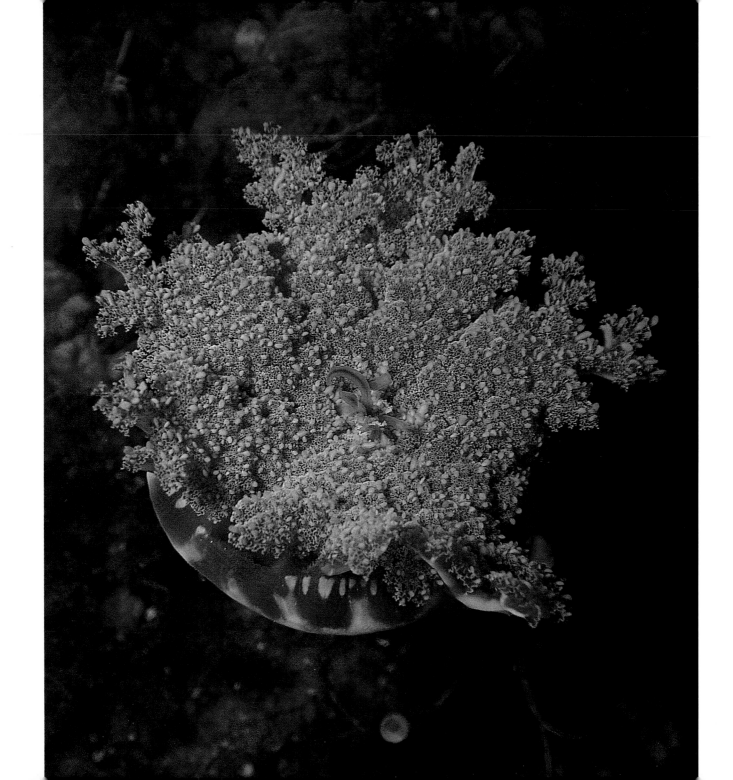

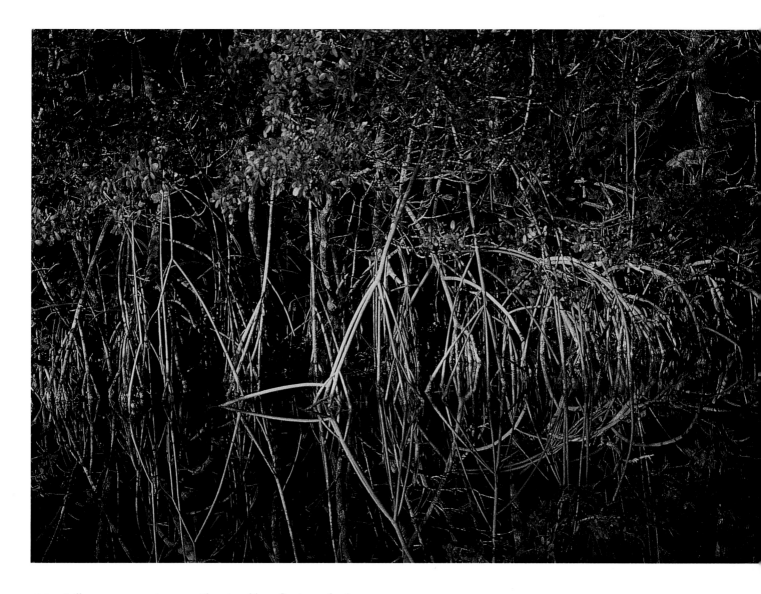

ABOVE: Still summer mornings provide mirrorlike reflections of red mangrove prop roots.

FACING PAGE: Upside-down jellyfish extending its tentacles to feed on plankton as it undulates through the shallow waters of Florida Bay.

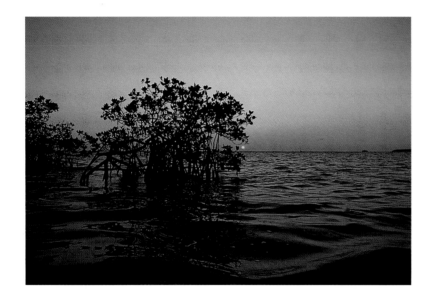

ABOVE: Red mangrove silhouetted by a Florida Bay sunset.

RIGHT: Dawn on the Anhinga Trail boardwalk—a magical time to experience the quiet solitude of the Everglades.

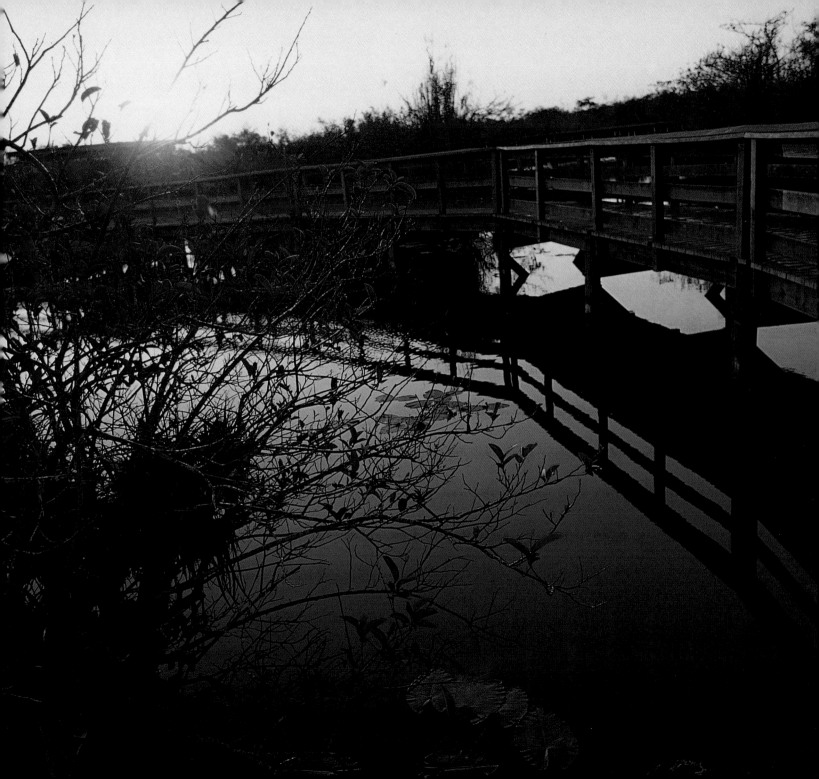

Flock of cormorants taking flight at dusk, headed for their nighttime roosts.

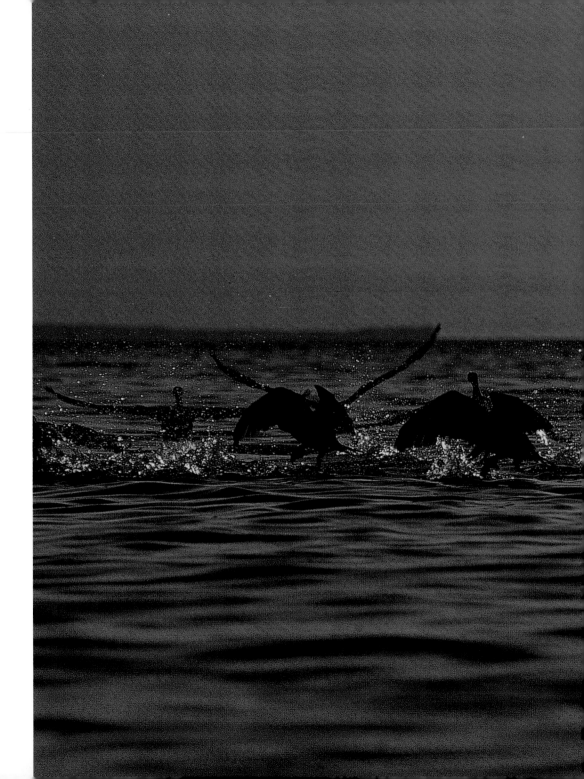

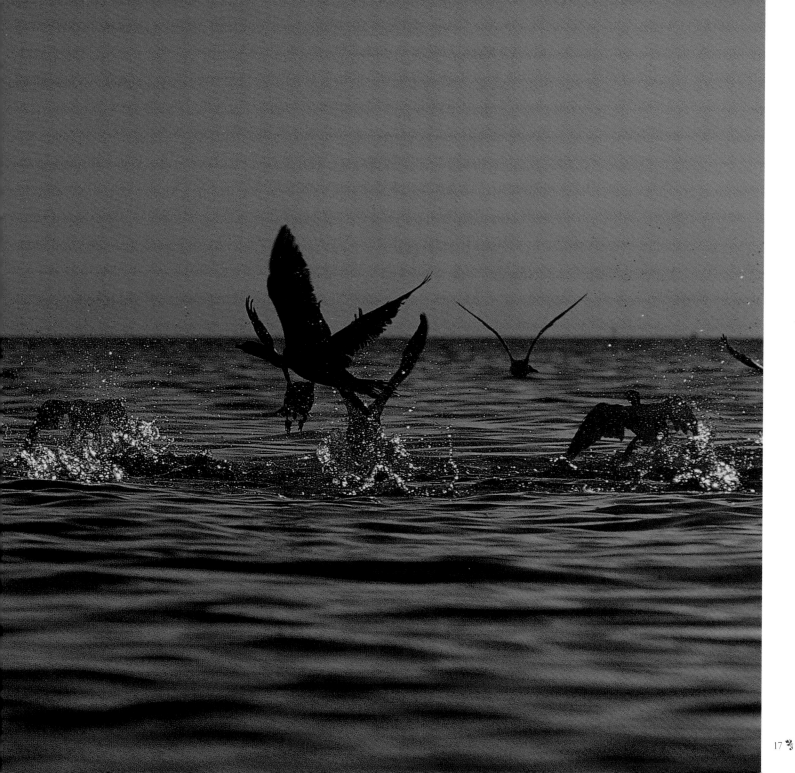

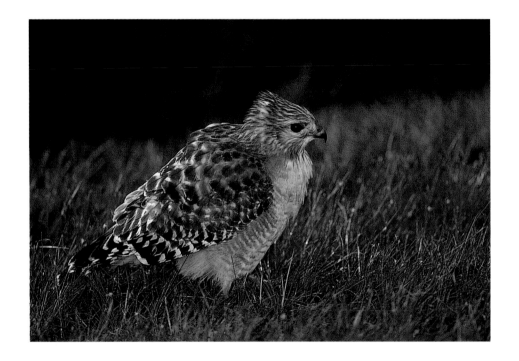

ABOVE: Red-shouldered hawk.

RIGHT: This sawgrass prairie near the Turner River is bordered by slash pines.

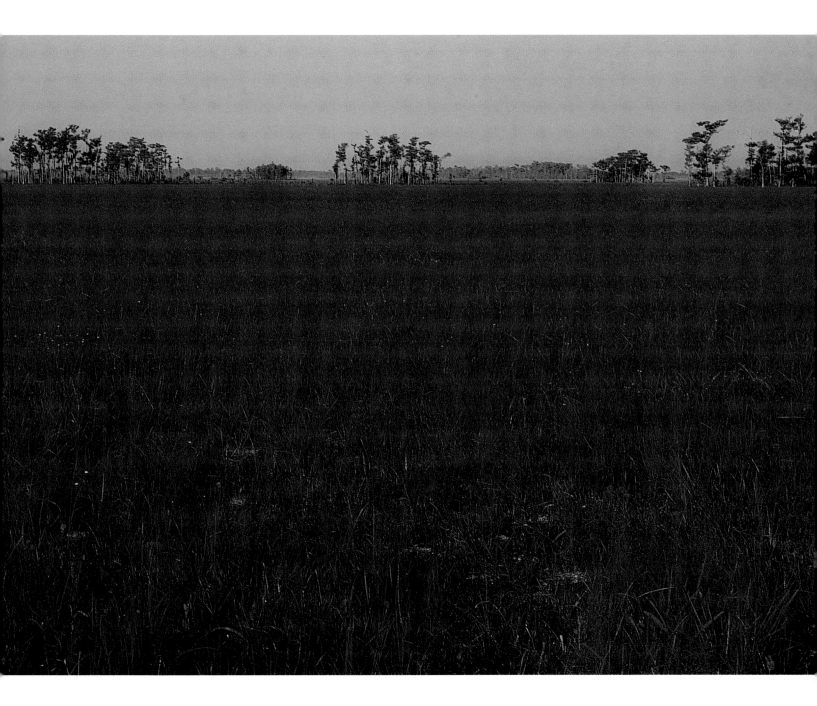

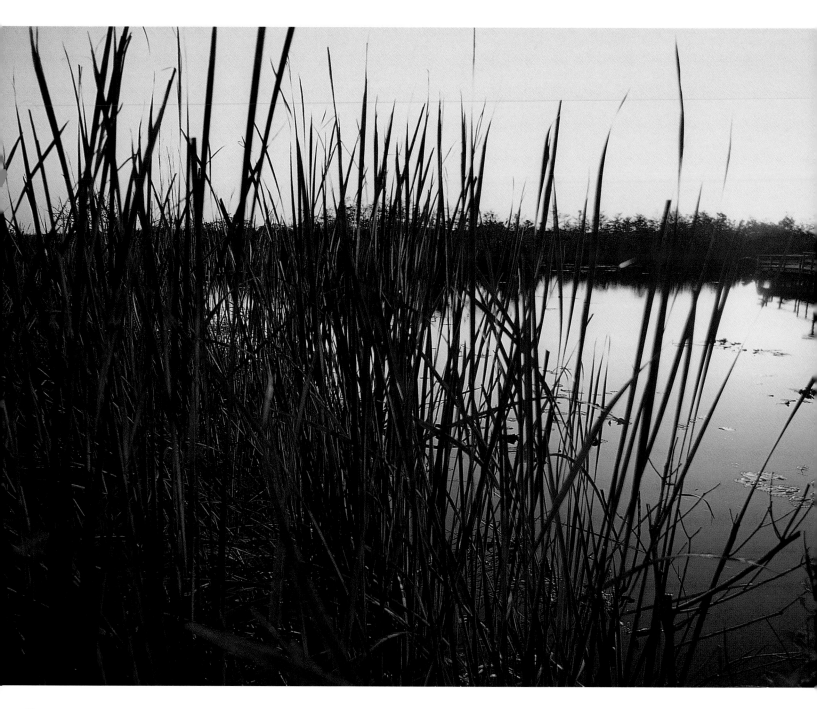

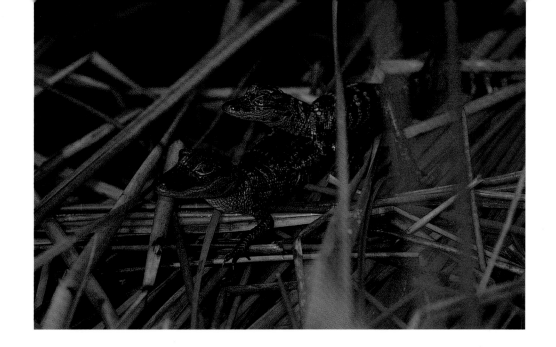

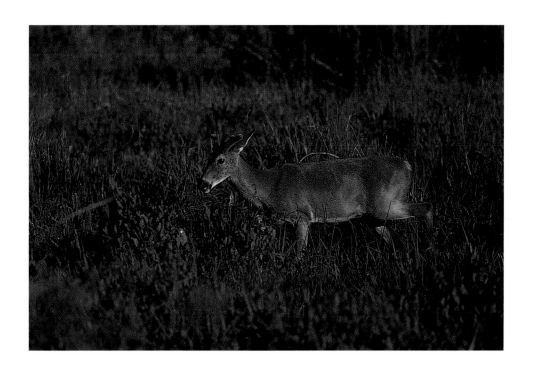

ABOVE: Baby alligators hiding in marsh reeds, Shark Valley.

LEFT: White-tailed deer feeding on wetlands vegetation, Shark Valley.

FACING PAGE: Marsh reeds frame a tranquil pond along the Anhinga Trail.

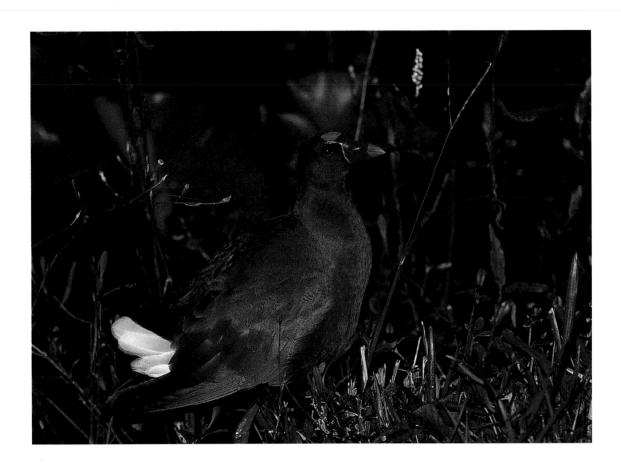

ABOVE: Brightly colored purple gallinules usually can be found wading on water lilies or in the safety of marsh vegetation.

RIGHT: Signs indicating Florida panther crossing areas have helped prevent further loss of this endangered species.

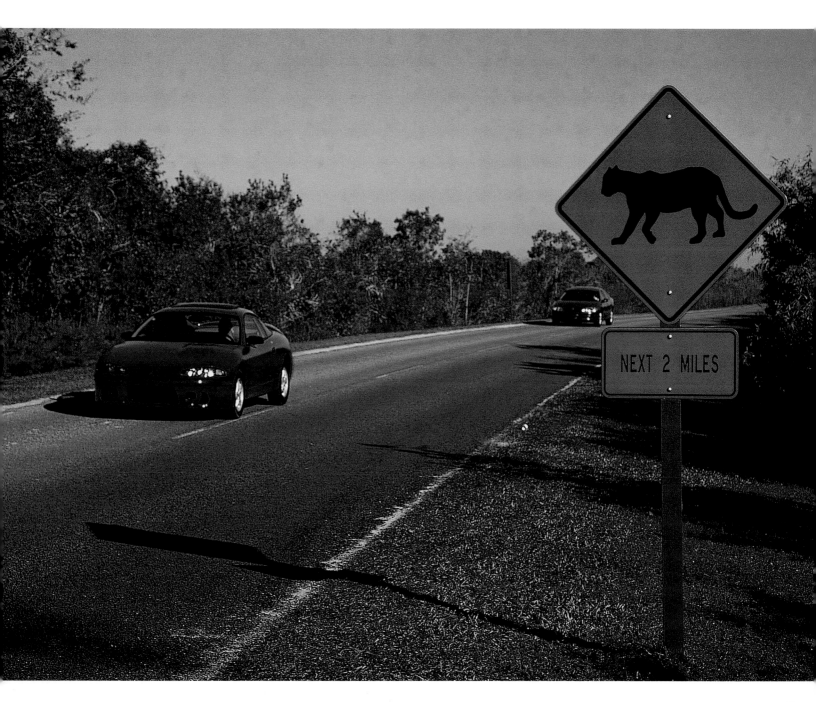

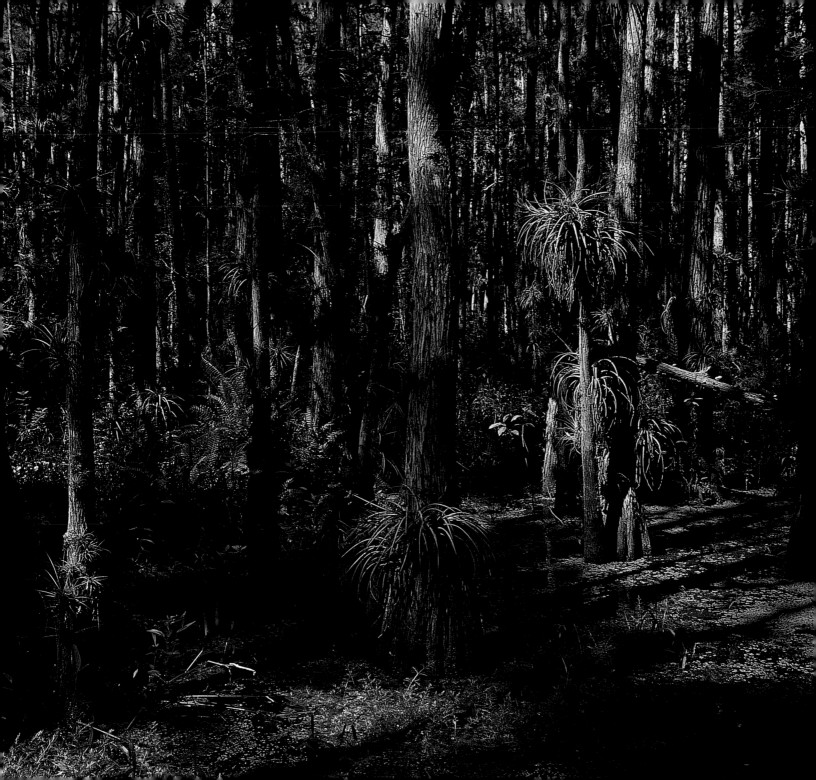

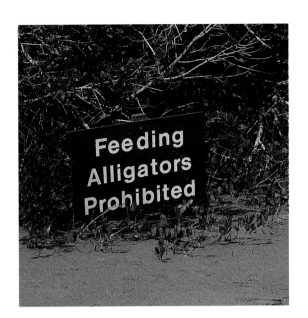

LEFT: Not only is feeding alligators dangerous, it creates problems by enticing alligators to overcome their natural shyness. Feeding alligators is also a violation of Florida state law.

FAR LEFT: The quiet, sun-dappled interior of a cypress slough is a magical place.

BELOW: The seemingly docile, "sit and wait" predatory behavior of the American alligator should not be taken for granted; they can be lightning quick and are able to outrun a human for short distances.

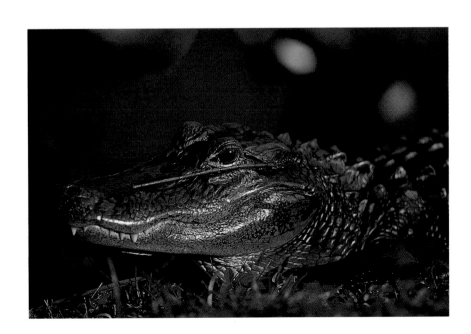

FACING PAGE: A waterway meanders through the Ten Thousand Islands region near Chokoloskee.

BELOW: Great blue heron, perched on a mangrove, surveying the sawgrass prairie, Shark Valley.

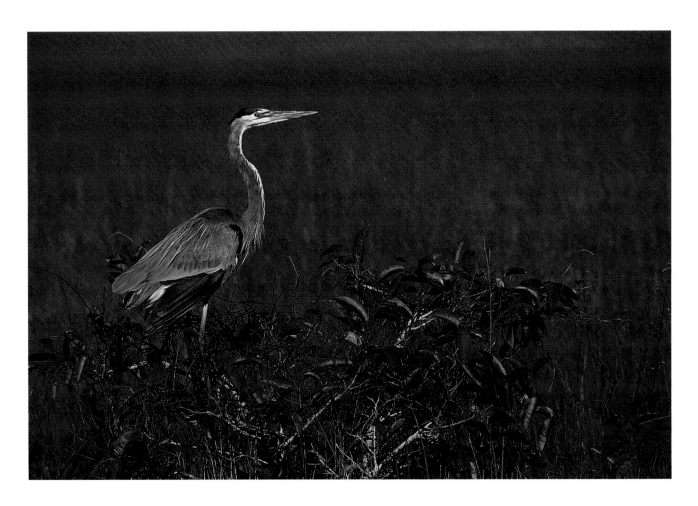

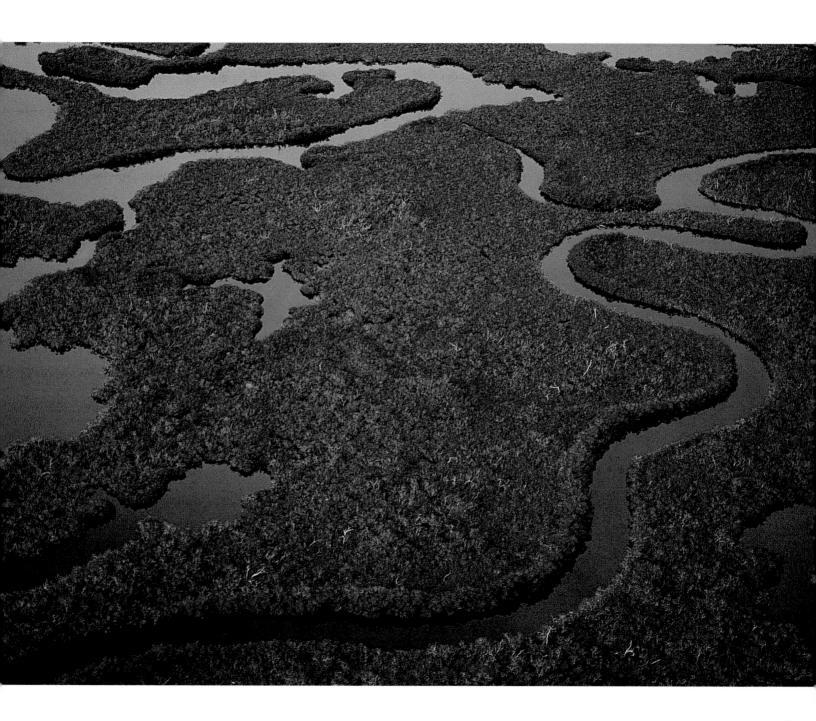

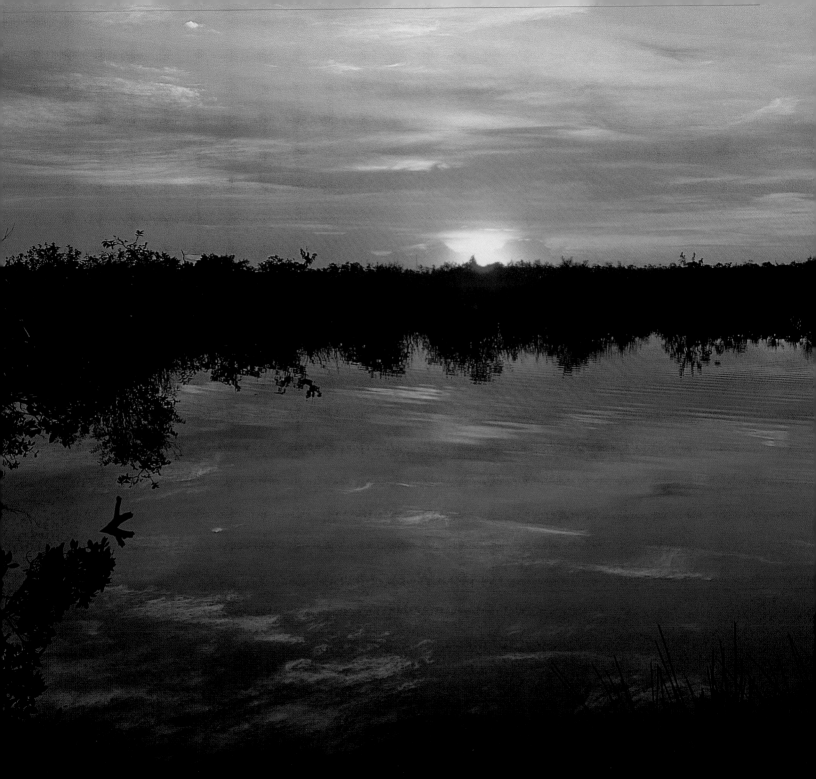

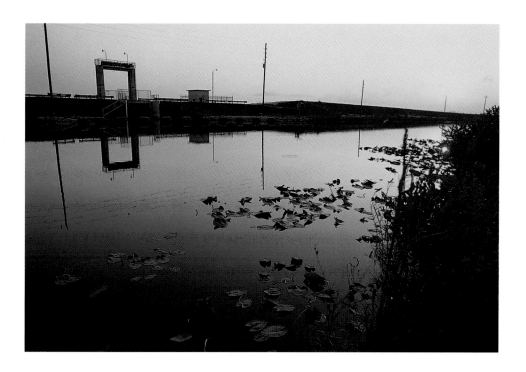

ABOVE: Nearly 1,000 miles of levees, dams, canals, and pump stations were constructed by the U.S. Army Corp of Engineers in 1948 to prevent flooding and protect agricultural areas from saltwater intrusion.

LEFT: Water levels play a crucial role in the life cycles of Everglades flora and fauna. High water during the summer rainy season provides an environment for breeding fish.

RIGHT: Endangered wood stork, with a 5-foot wingspan, preparing for flight at Paurotis Pond.

FAR RIGHT: The lush green of a moist summer morning saturates the landscape at Anhinga Trail.

BELOW: The most rare of heron species in North America, the reddish egret is renowned for its comical, frenetic feeding behavior.

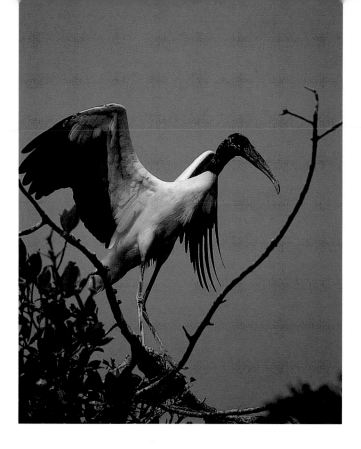

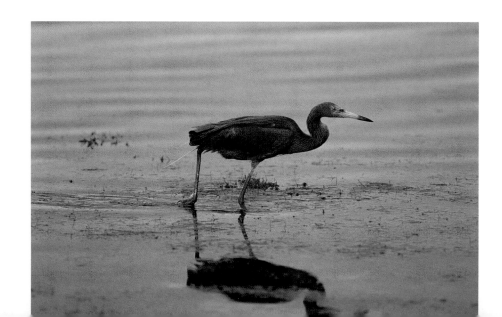

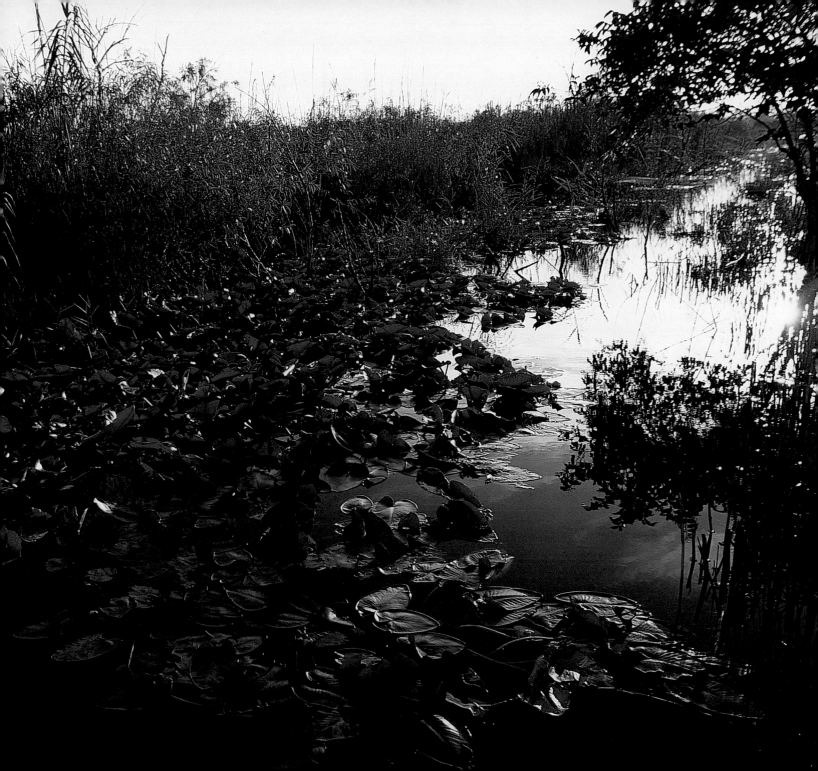

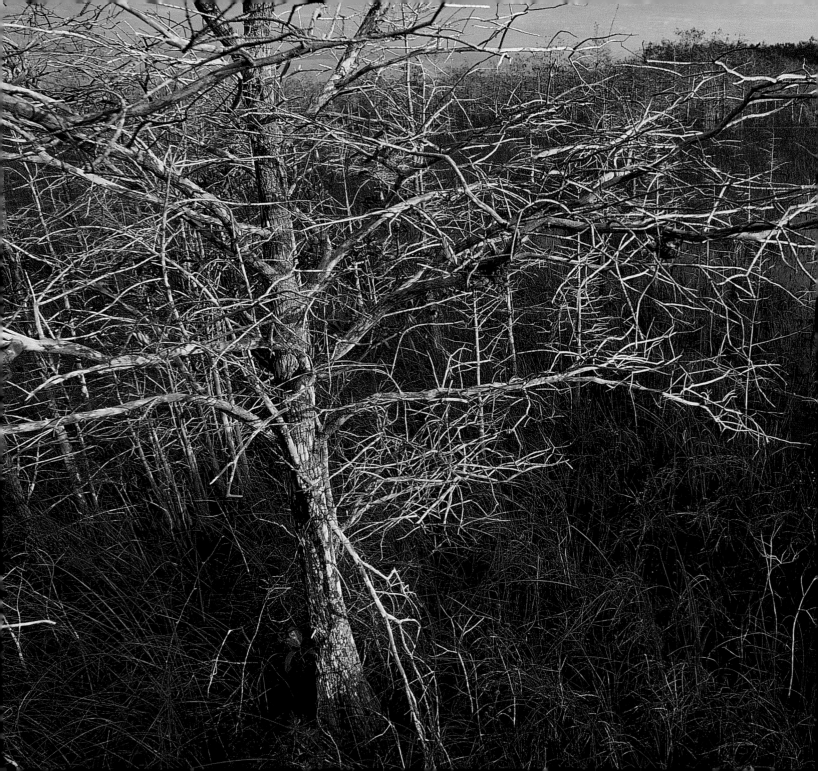

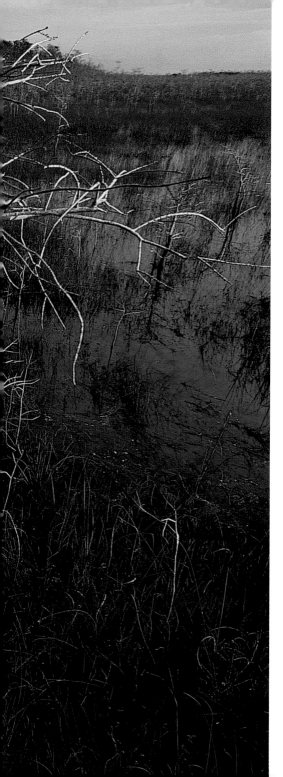

LEFT: Sun-bleached dwarf cypress trees, some of which may be nearly a century old, can be seen at the Pa-hay-okee Overlook.

BELOW: Green heron eyeing the water for a meal.

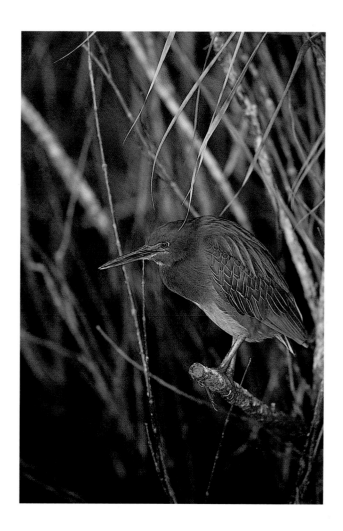

RIGHT: Blue crab foraging for food in the turtle grass at the base of a red mangrove in Florida Bay.

BELOW: Manatee resting on its pectoral flippers.

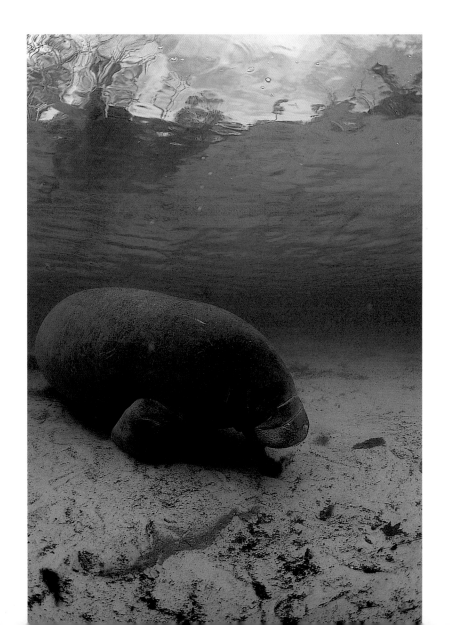

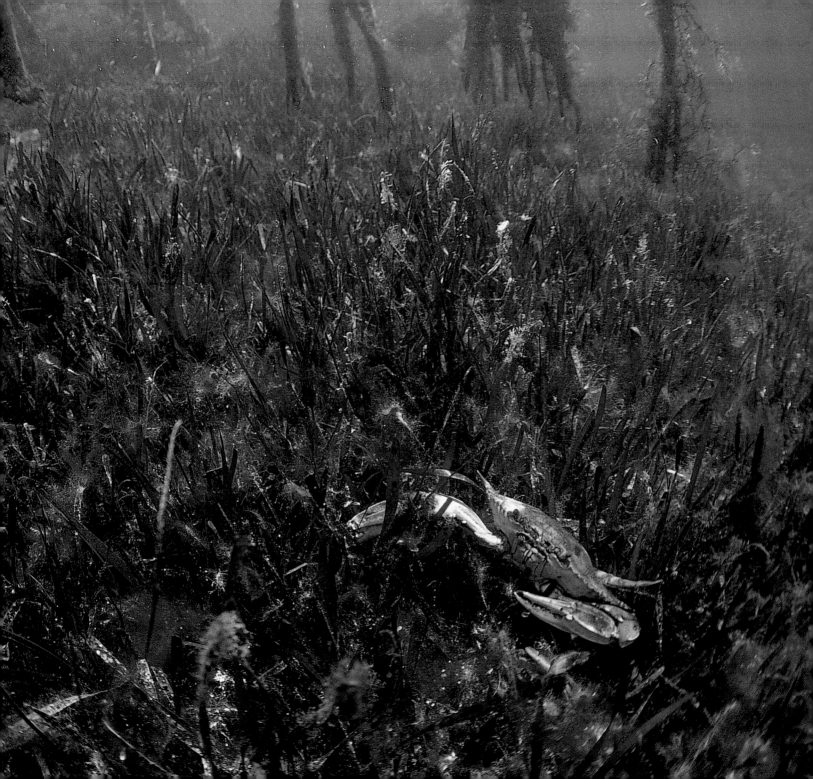

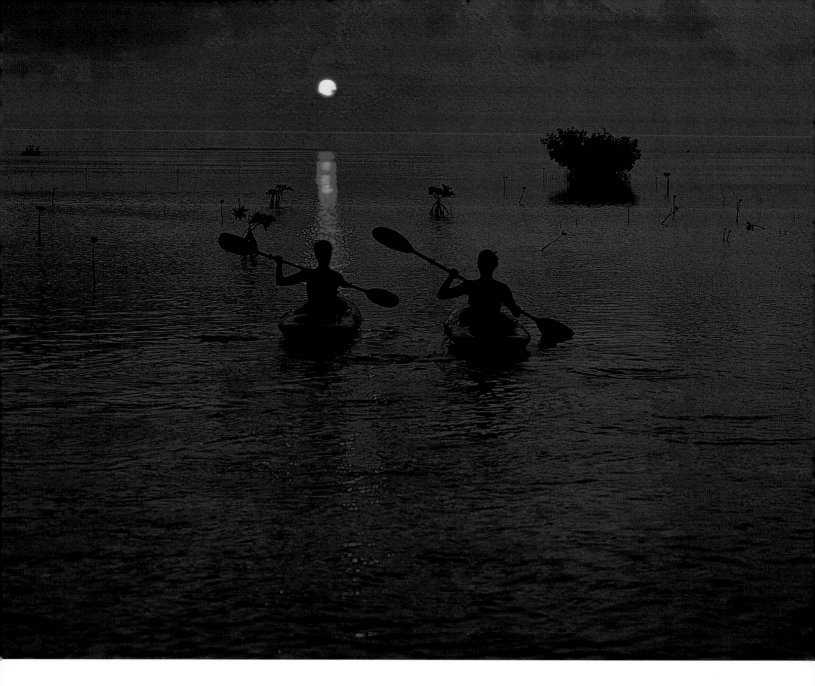

Kayakers enjoy a moment of solitude as the sun sinks into Florida Bay.

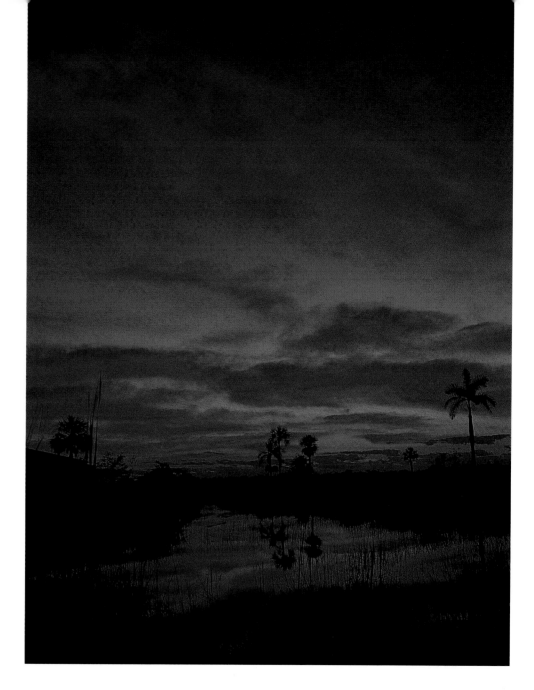

Predawn colors saturate the sky.

RIGHT: Male magnificent frigatebird
inflates his red throat pouch during
courtship.

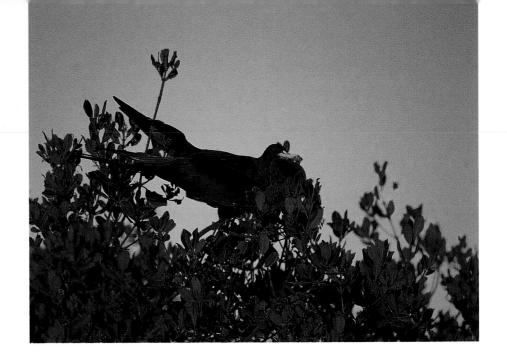

BELOW: Purse oyster nestled in a bed
of algae.

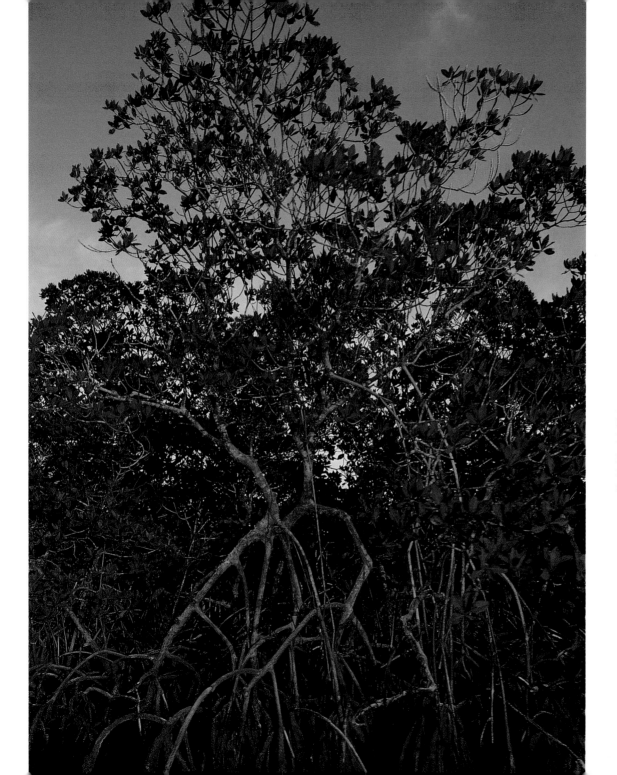

Acting as a buffer between sea and land, red mangrove prop roots form a mesmerizing maze as they take root.

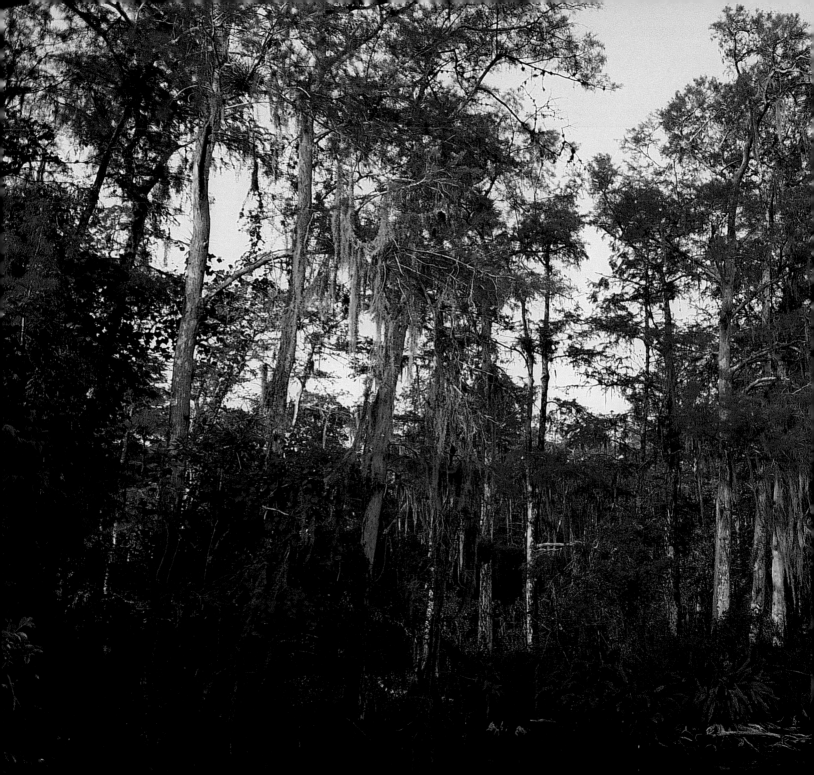

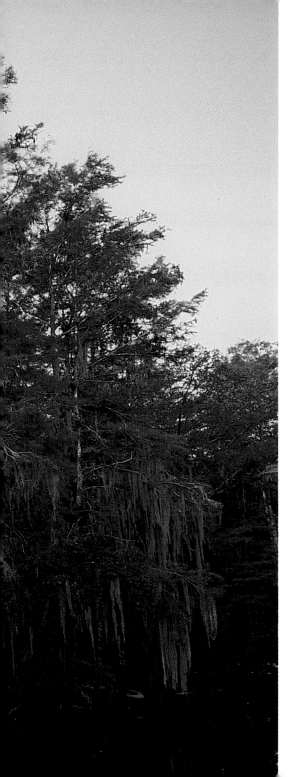

LEFT: Bald cypress trees draped with Spanish moss.

BELOW: These pneumatophores are part of the air-breathing underground cable root system of the black mangrove.

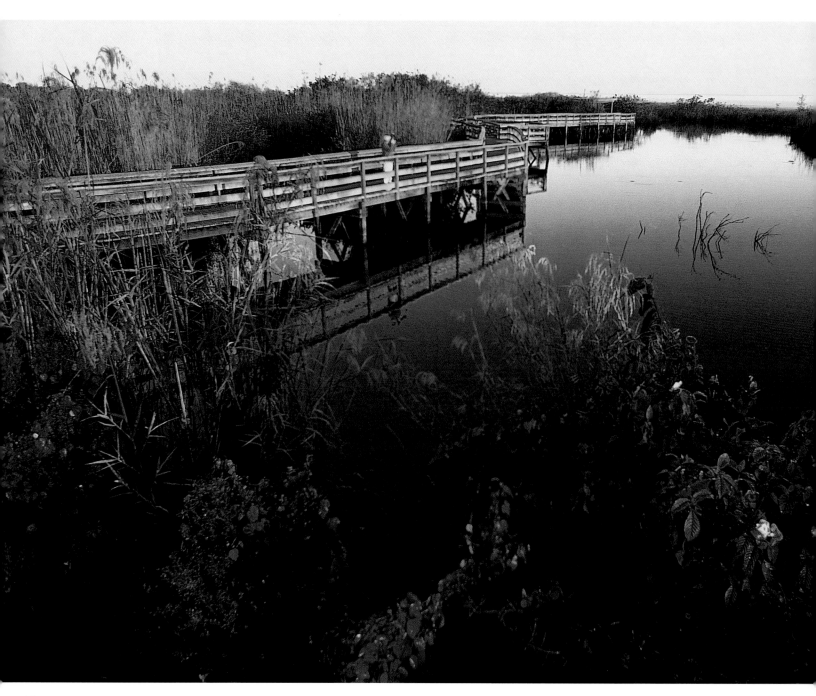

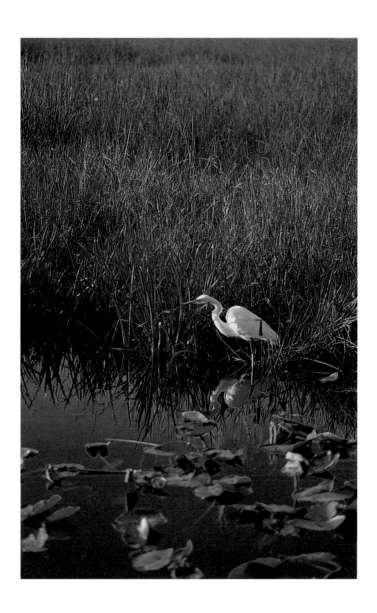

LEFT: Great egret carefully stalking breakfast at the edge of a sawgrass prairie.

FAR LEFT: The boardwalk portion of Anhinga Trail at the Royal Palm Visitor Center provides excellent access to the wetlands areas.

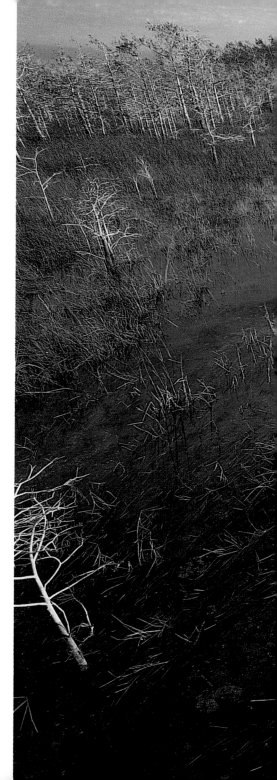

RIGHT: Water flowing southward through the sawgrass is evident at Pa-hay-okee, making it easy to see why the Everglades is often referred to as the "River of Grass."

BELOW: Once decimated by the pesticide DDT, which causes pelicans to lay thin-shelled eggs that break during incubation, brown pelicans have staged a remarkable comeback since the pesticide was banned in 1972.

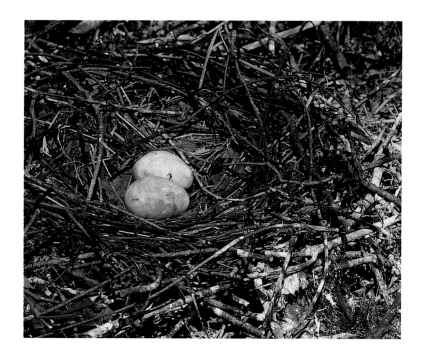

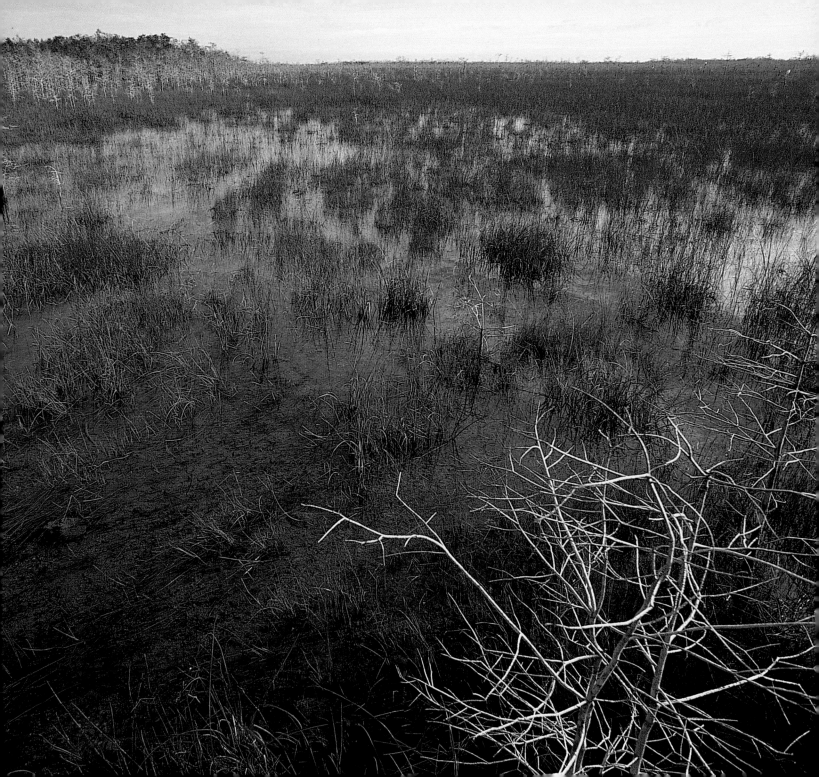

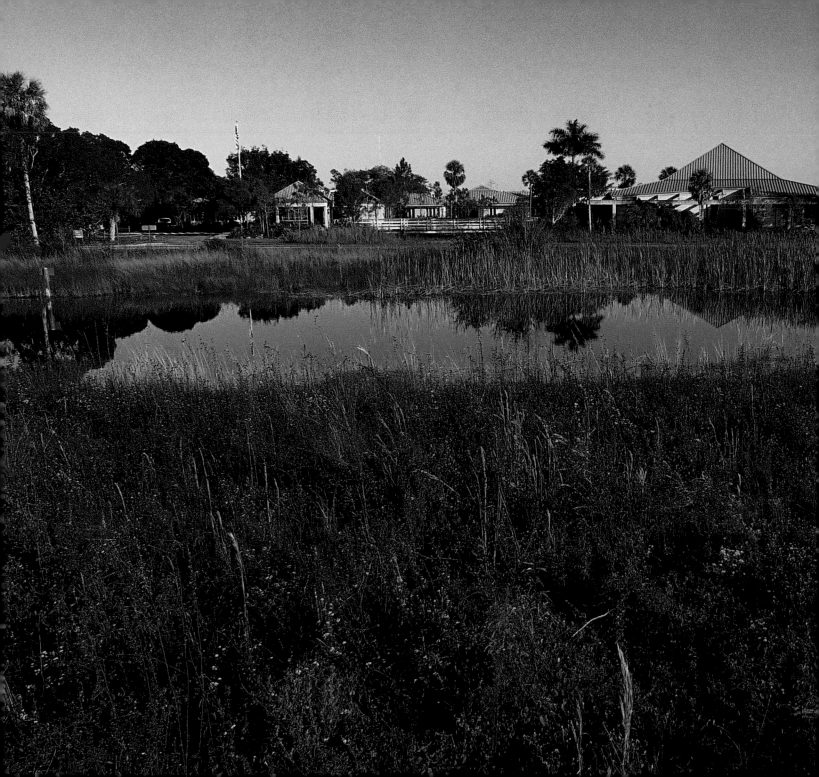

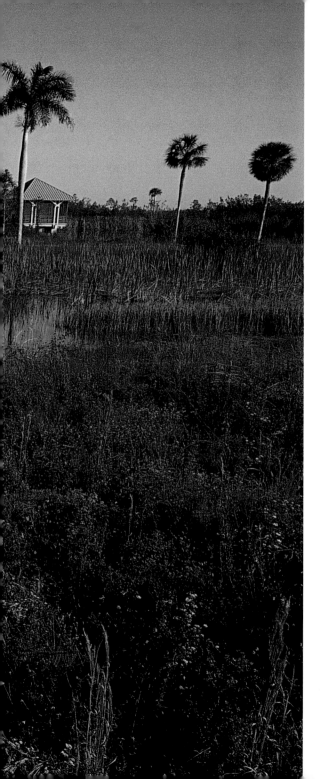

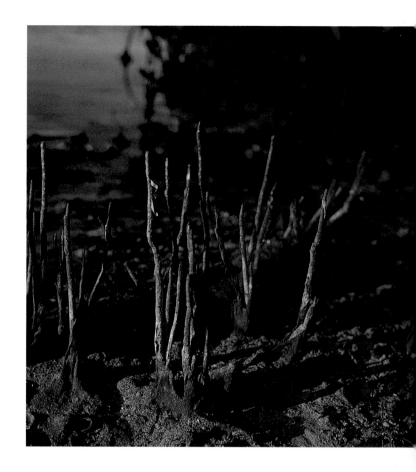

ABOVE: Pneumatophores are the black mangrove's "breather roots," part of a vast cable root network that also traps estuarine silt and prevents erosion.

LEFT: The Ernest F. Coe Visitor Center facilities are located at the main Everglades National Park entrance at Florida City/Homestead.

RIGHT: An underwater close-up view of red mangrove prop roots reveals that they play host to a variety of marine invertebrates and algae.

BELOW: Florida red-bellied cooter basking in the sun.

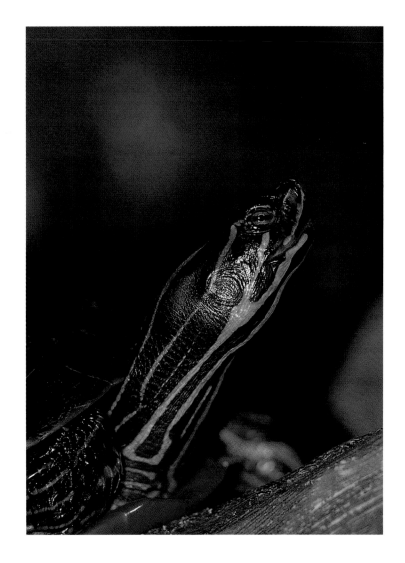

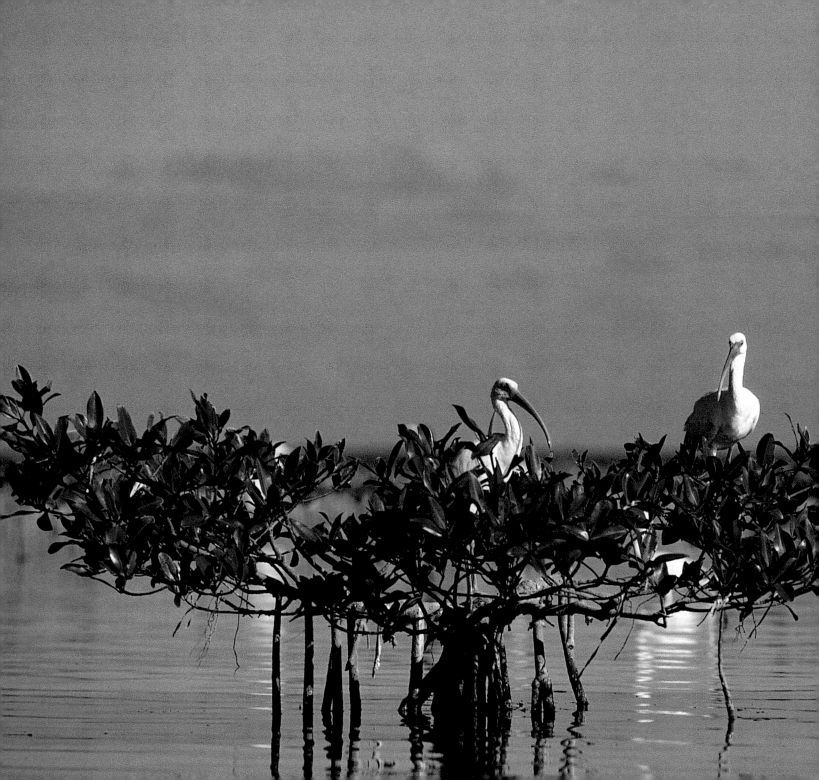

LEFT: White ibis pair surveying the shallows of Florida Bay from an accommodating red mangrove.

BELOW: Tri-colored heron clinging to a mangrove branch for support on a windy day.

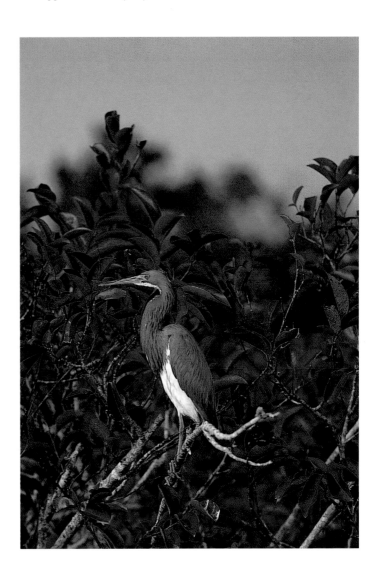

BELOW: Sniffing the evening air, a young bobcat cautiously peers out from a hardwood hammock thicket.

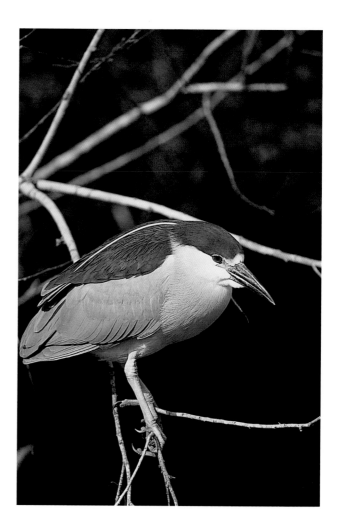

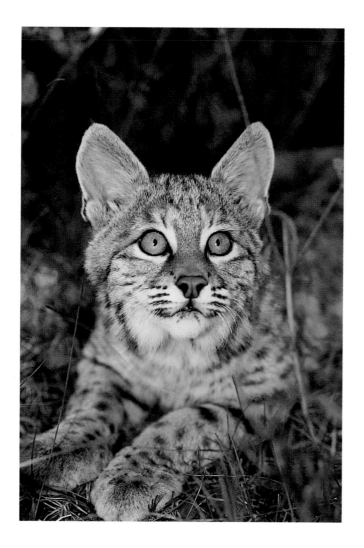

ABOVE: Black-crowned night heron preparing to hunt at the end of the day.

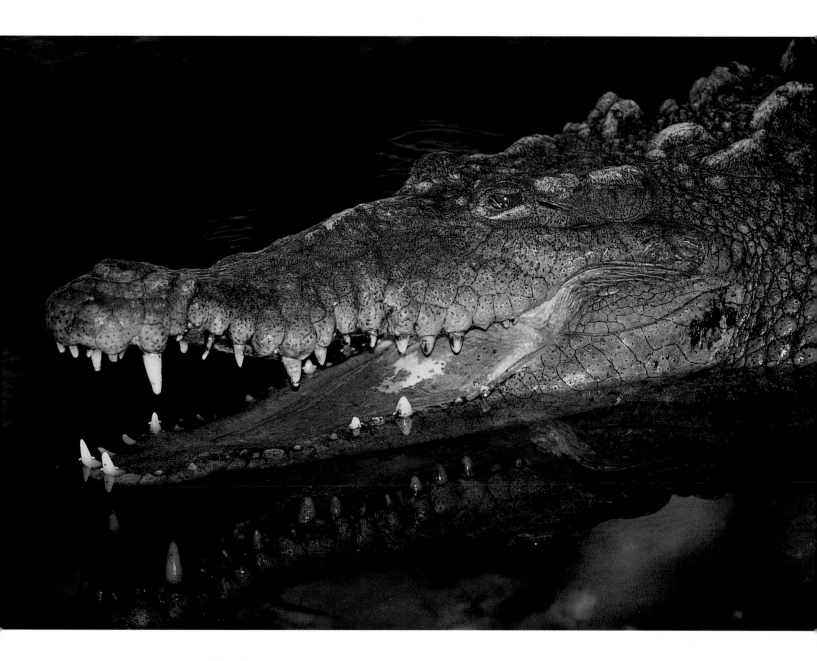

The best place to view the endangered American crocodile is along the shore of Florida Bay at the Flamingo Visitor Center.

RIGHT: Morning sun burns off the ground fog at a slash pine forest.

BELOW: A brightly colored sponge filter-feeds on microscopic plankton in the shallows of Florida Bay.

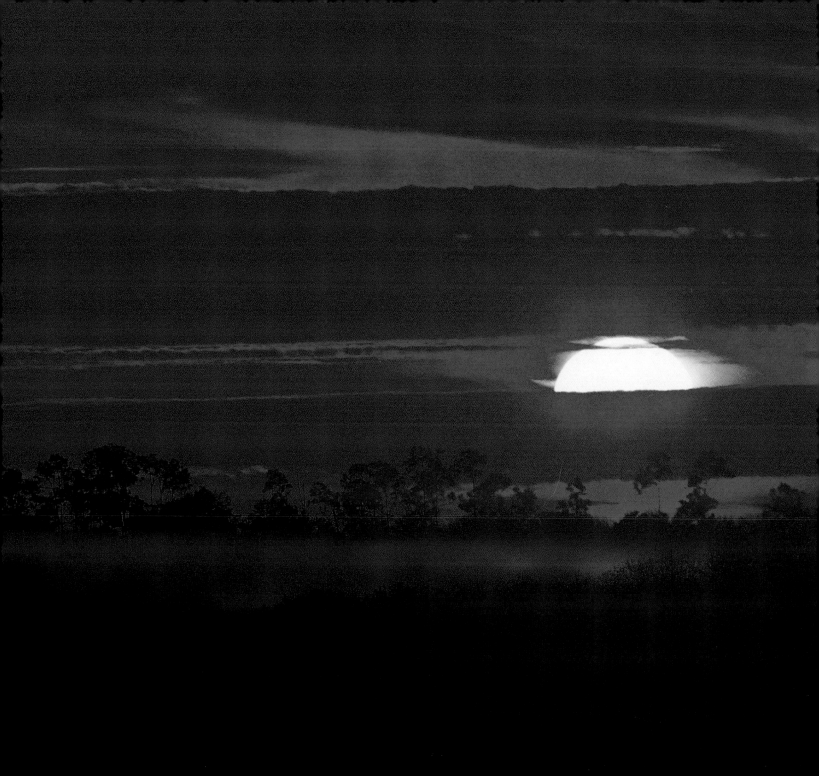

RIGHT: Roseate spoonbills were driven to the verge of extinction by feather hunters a century ago. First-time visitors often mistake the spoonbill for a flamingo as they watch stunning pink wings flash against the blue sky.

BELOW: The endangered wood stork feeds by a method known as "tacto-location," moving its partially opened bill back and forth in the water while feeling for fish. The bill instantly snaps shut when prey is detected—at 25 milliseconds, the fastest known vertebrate reflex action.

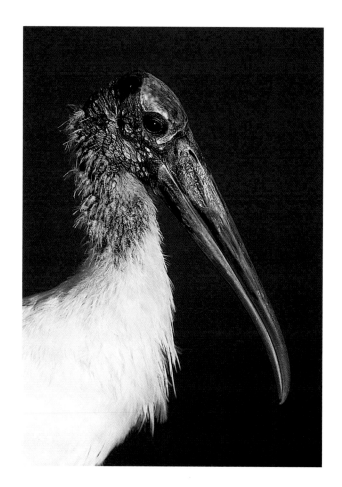

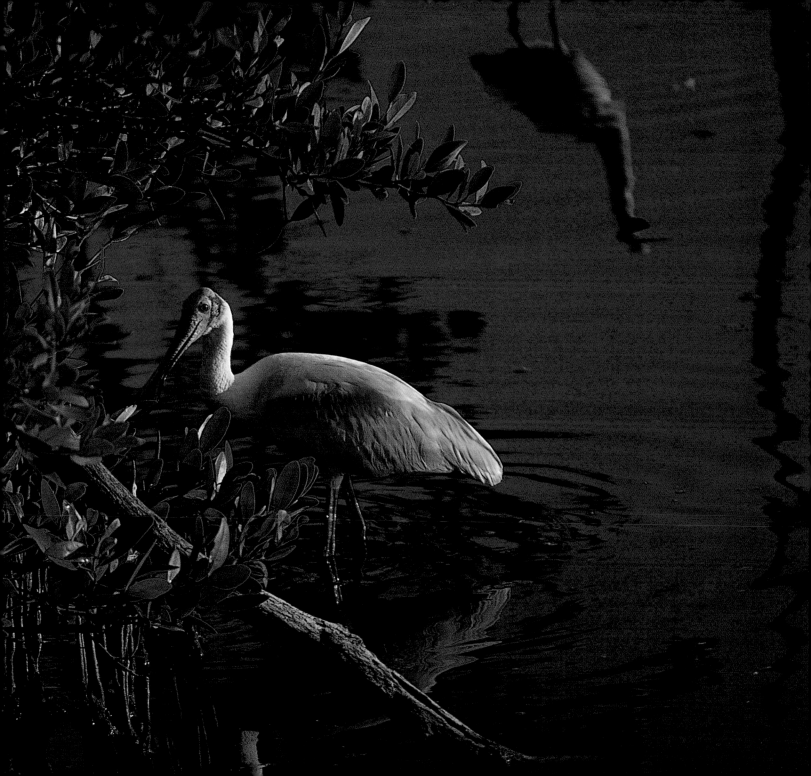

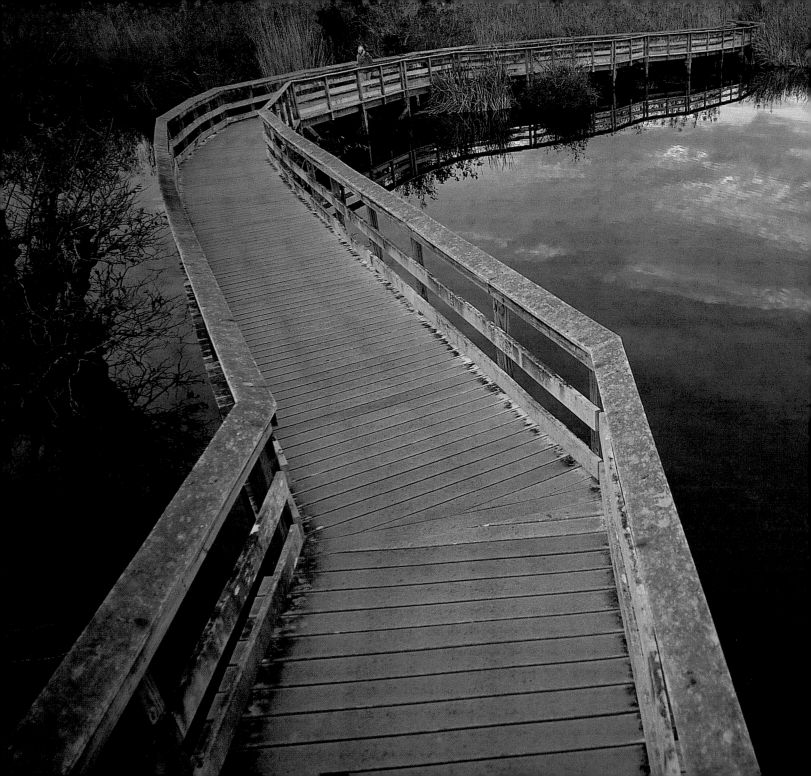

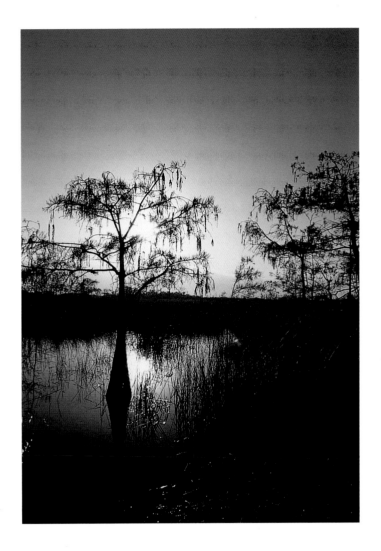

ABOVE: Dawn silhouettes a dwarf cypress at Pa-hay-okee.

LEFT: The Anhinga Trail boardwalk winds through the "River of Grass." In the distance is the Royal Palm Visitor Center.

RIGHT: Great white heron
perched proudly atop a
mangrove.

FACING PAGE: Red mangroves'
unusual prop roots have
earned them the title of
"walking trees."

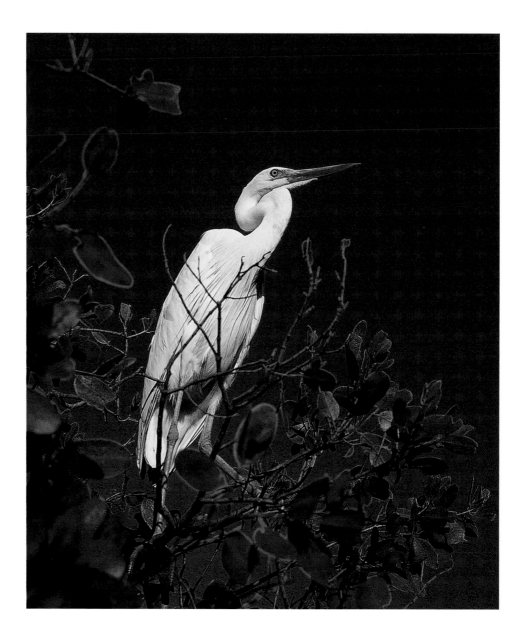

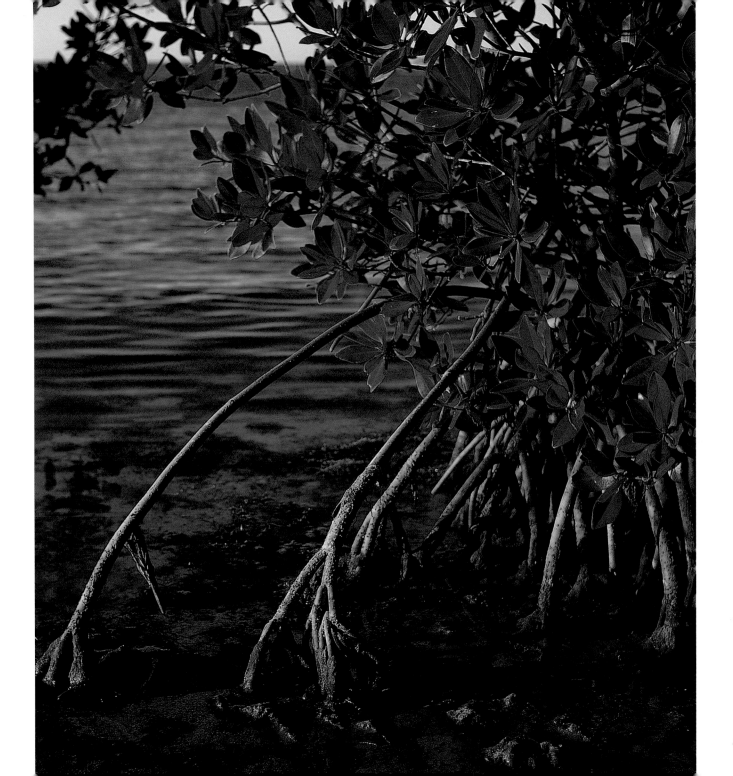

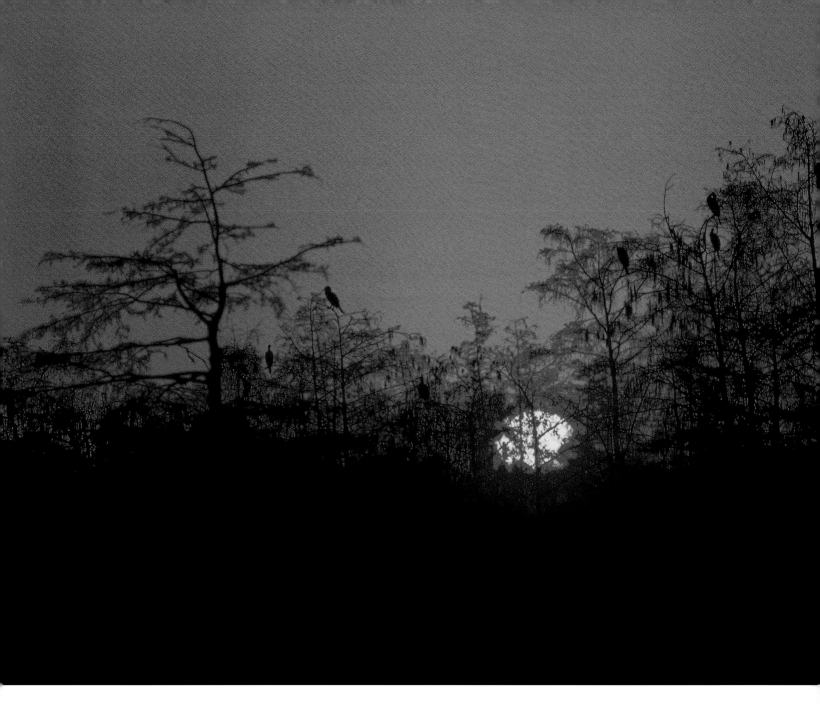

Roosting birds awaiting the warmth of sunrise.

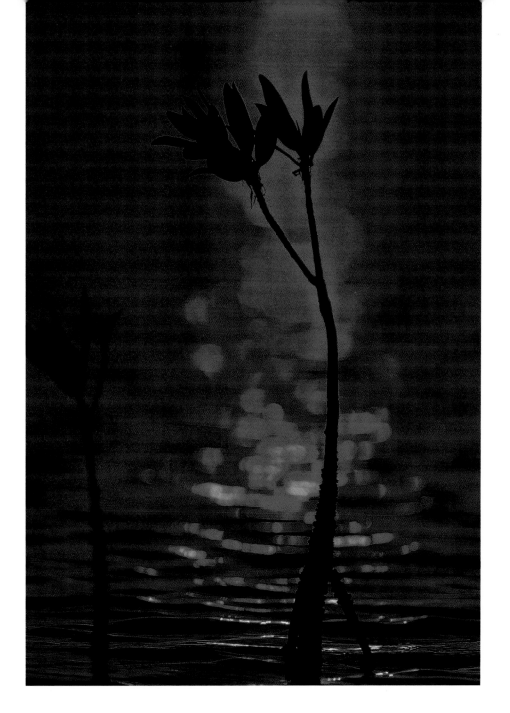

Red mangrove taking hold in the shallows of Florida Bay.
Its roots will provide a nursery area for crustaceans and fish.

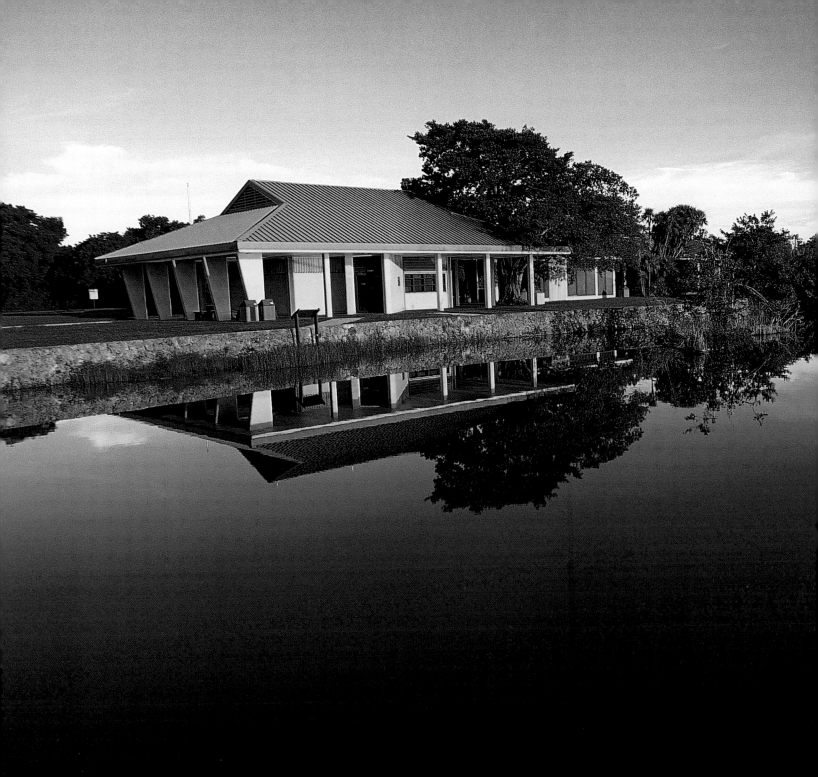

RIGHT: Barred owls are opportunistic hunters, sometimes seen foraging before dark.

LEFT: The Royal Palm Visitor Center is the starting point for the half-mile-long Anhinga Trail and adjacent Gumbo Limbo Trail.

BELOW: Stone crab peeking from beneath a mangrove root.

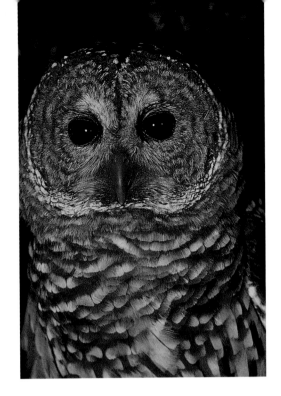

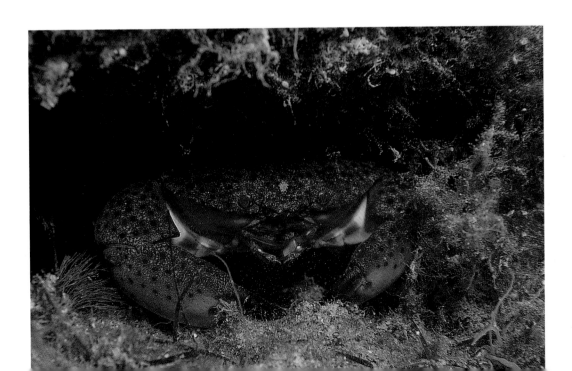

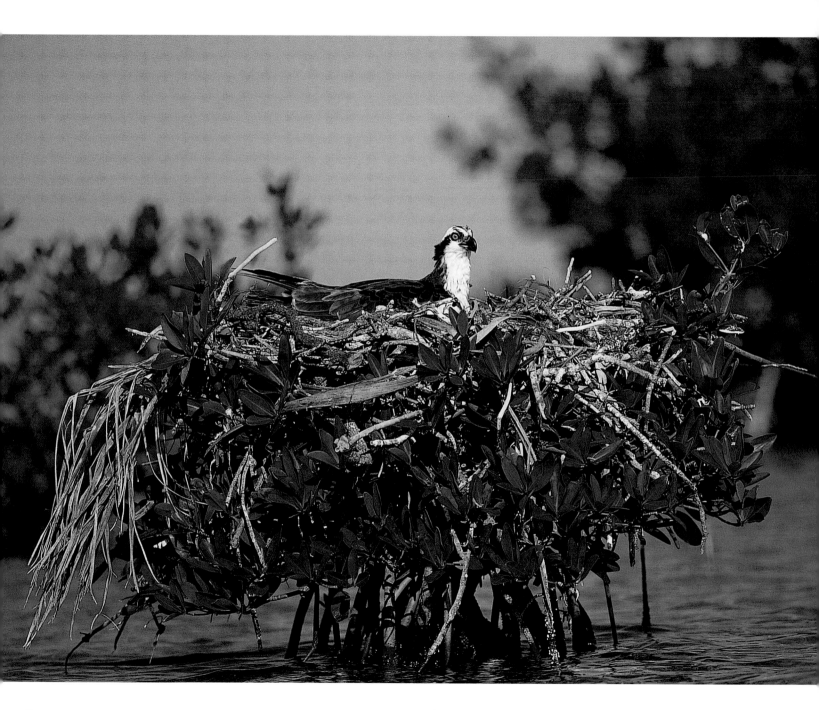

LEFT: Osprey incubating her eggs in a nest built on a low red mangrove.

BELOW: This softshell turtle, with its long tubular nose and leathery shell, is certainly an unusual sight.

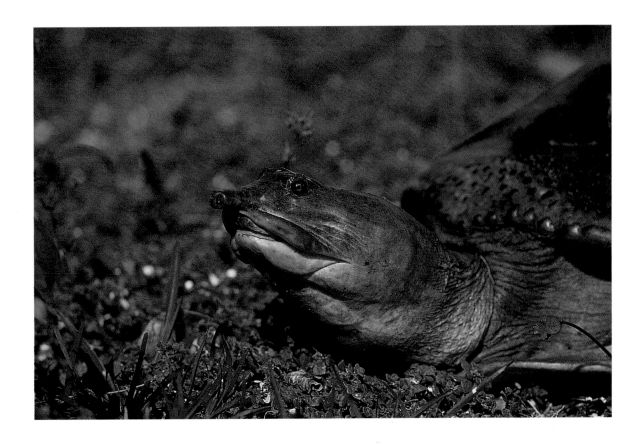

RIGHT: Laden with dew, a spider web glistens at sunrise.

FAR RIGHT: Cattails rim the edge of a quiet pond.

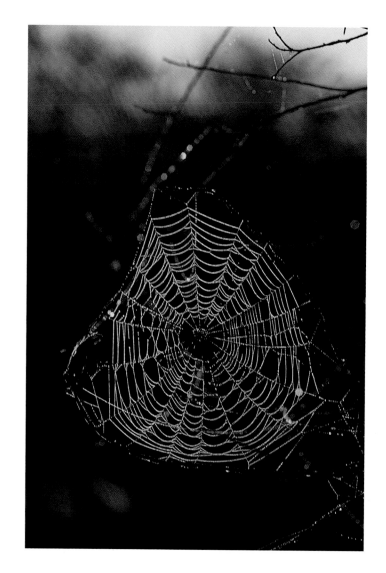

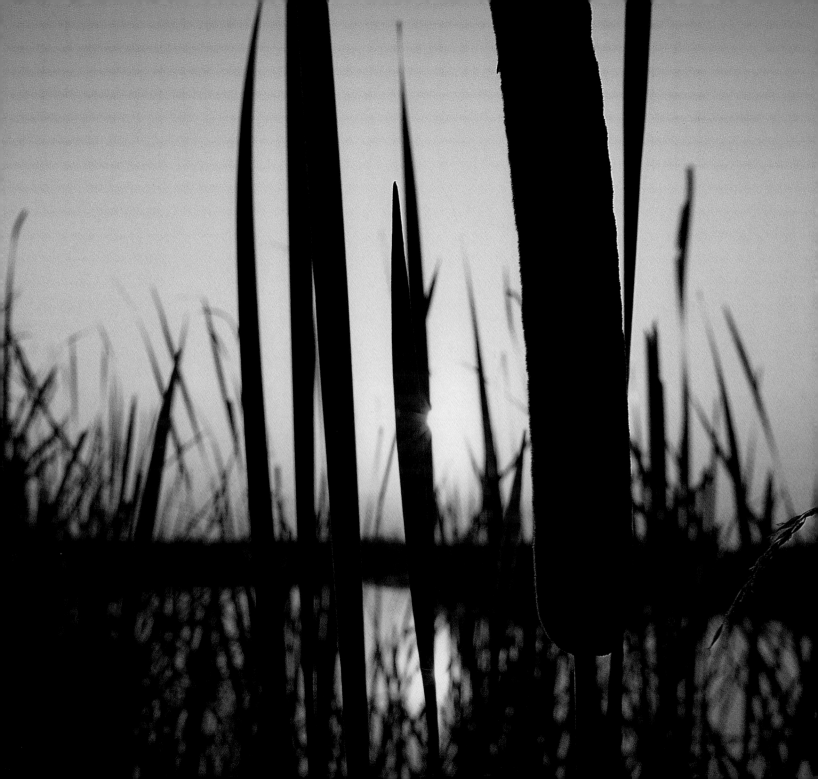

LEFT: While they may appear to be sponges, colonial mangrove tunicates are actually primitive vertebrates—the larval stage exhibits a primitive spinal cord.

BELOW: Statuesque great egret surveying Florida Bay at dusk.

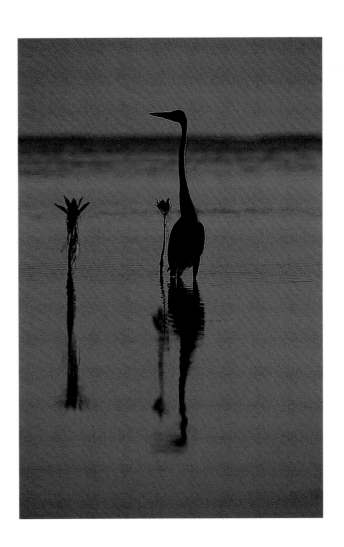

RIGHT: White ibis, a wading feeder, roosting at Paurotis Pond.

FAR RIGHT: Glimpse inside a serene cypress dome.

BELOW: Rarely observed, greater flamingos can sometimes be seen at Snake Bight east of the Flamingo Visitor Center or offshore at Sandy Key.

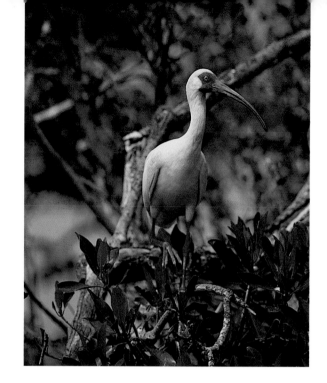

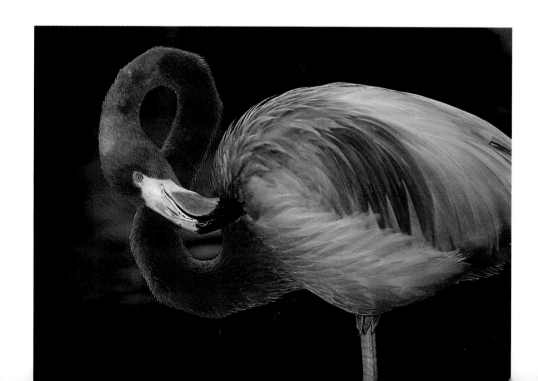

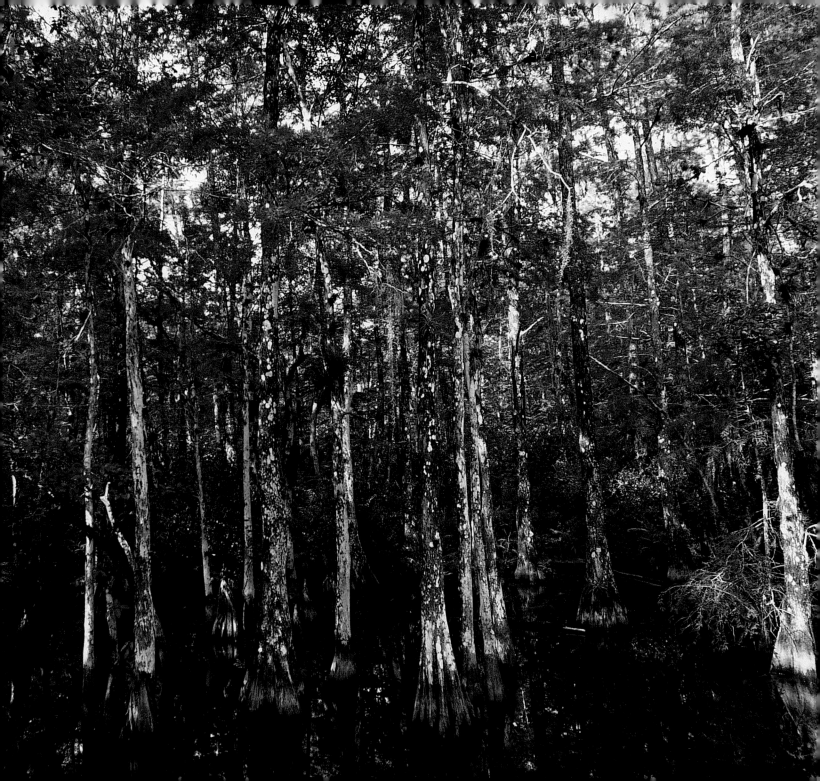

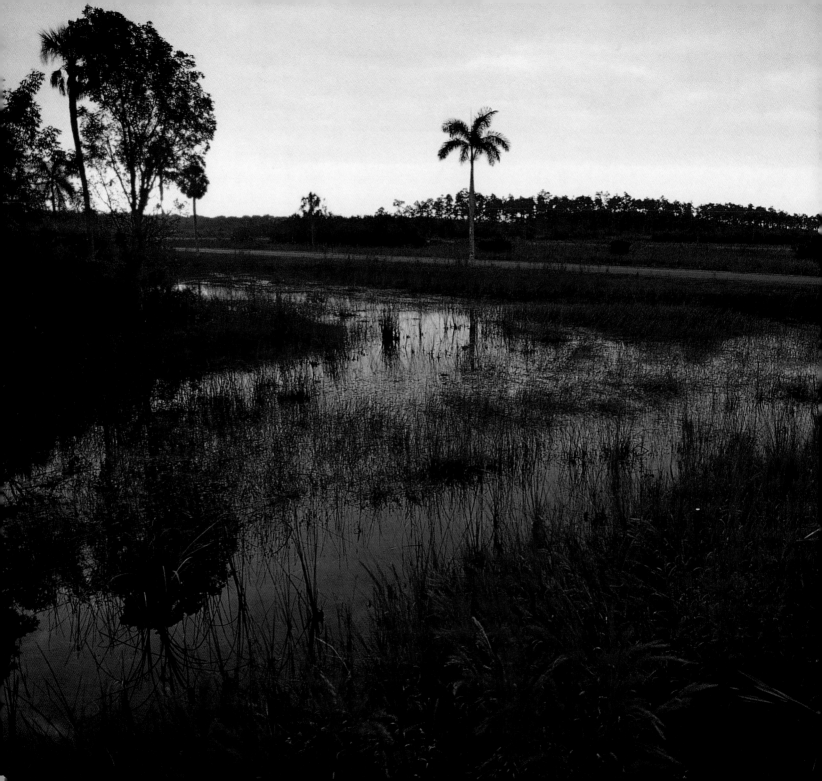

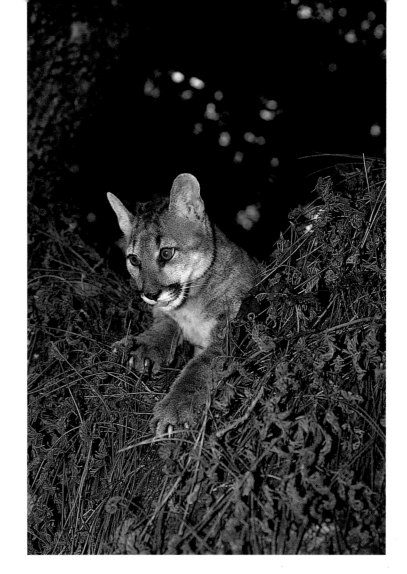

ABOVE: Florida panther kitten, poised and ready to explore the world of the Everglades.

LEFT: First light glimmers off a pond at the Ernest F. Coe Visitor Center.

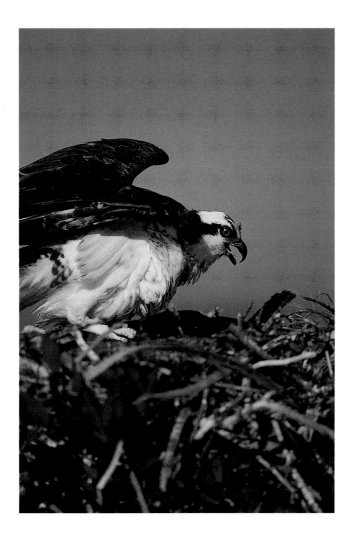

ABOVE: The high-pitched chirp of a female osprey announces her return to the nest.

FACING PAGE: The future of the Everglades depends heavily on proper water management.

BELOW: A research biologist with an endangered female American crocodile.

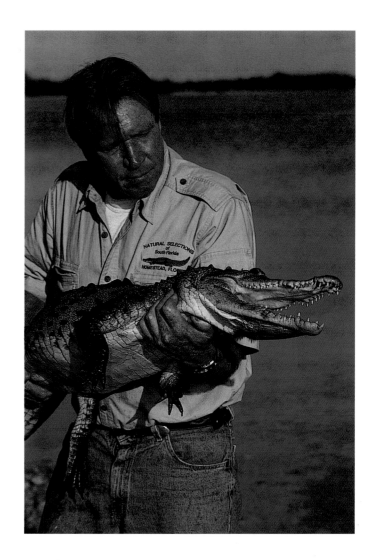

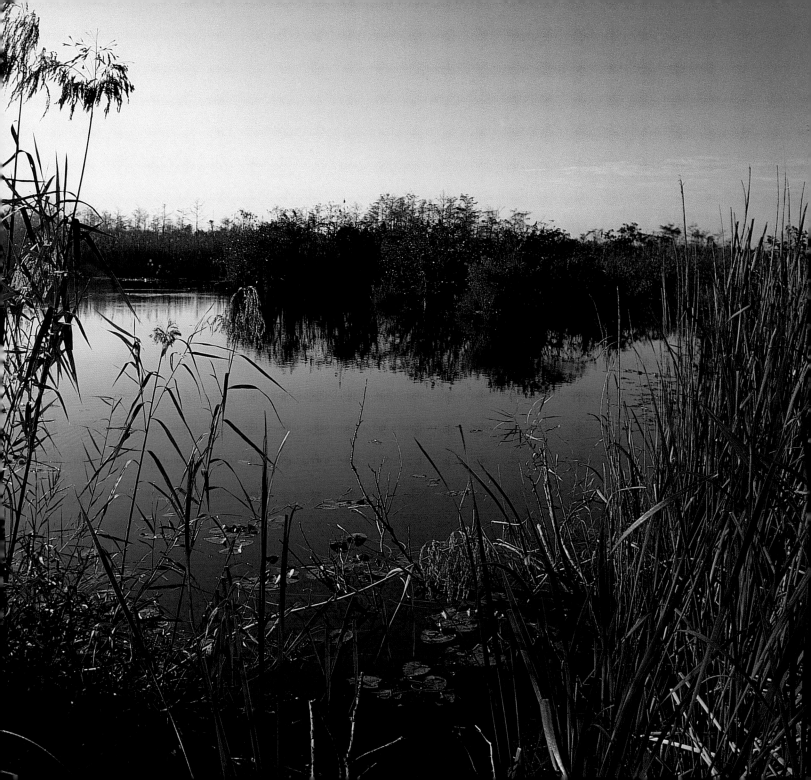

RIGHT: Great blue heron striking a proud pose along the Shark Valley Trail.

FACING PAGE: The Park's historic entrance sign hints at the many wonders that lie ahead.

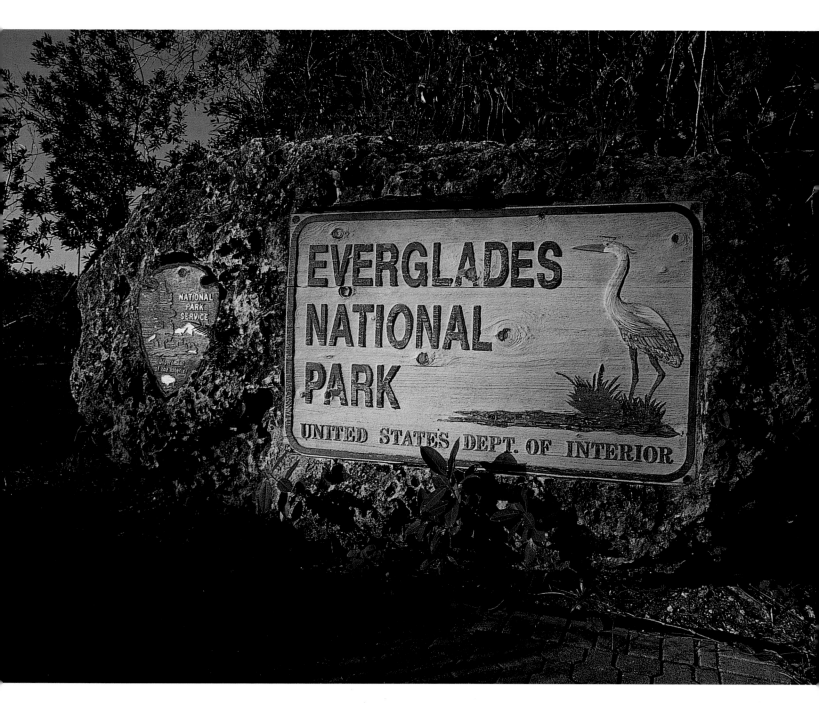

Respected as one of the world's most widely published photography couples, Tom and Therisa Stack are full-time professionals with more than thirty-five years of experience. From their home base in Key Largo, they journey on frequent assignments throughout the Florida Keys and Caribbean. They work closely with National Oceanic and Atmospheric Administration and Florida Keys National Marine Sanctuary researchers who are actively involved with the preservation of the fragile coral reef and mangrove ecosystems.

Their photography has been published in *National Geographic, National Wildlife, Audubon, Sierra, Travel & Leisure, Islands, Travel Holiday, Outside, Backpacker, Nature Conservancy, National Parks, Blue Planet, Scuba Diving, Sport Diver, Geo, Canoe & Kayak, Yachting, Power & Motoryacht,* Discovery Channel Guides, Hallmark and American Greetings calendars, *Encyclopaedia Britannica, Encarta,* and many other books and magazines.

www.tomstackphoto.com